Social Media Marketing for Beginners

How to Use Social Media for Business and Content Creation Essentials in 2020. A guide to Become an Influencer and Maximize Your Success Online with Digital Marketing

Miller J. McDonald

Disclaimer Notice:

Please note the information contained within this document is for educational and entertainment purposes only. All effort has been executed to present accurate, up to date, reliable, complete information.

No warranties of any kind are declared or implied. Readers acknowledge that the author is not engaged in the rendering of legal, financial, medical or professional advice. The content within this book has been derived from various sources. Please consult a licensed professional before attempting any techniques outlined in this book.

By reading this document, the reader agrees that under no circumstances is the author responsible for any losses, direct or indirect, that are incurred as a result of the use of the information contained within this document, including, but not limited to, errors, omissions, or inaccuracies.

Table of Contents

Introduction

Entrepreneurship has become a way of life for many individuals in modern times. This is an excellent option for people who would prefer not to have a boss and build a business empire on their own. The majority of these people are risk-takers that see opportunities where others don't.

Starting a business as an entrepreneur or maintaining consistent growth of the company can be challenging for most people. The industry thrives on making sales to customers. If there is no increase in the number of loyal customers, there is a limit to how much the business can grow.

Despite your penchant for risk-taking, I know you understand that there are vital steps to take when growing a business. An example is engaging in various marketing campaigns.

One of the most influential forms of marketing in the world today is digital marketing.

Digital marketing is the use of a digital medium to promote your business or product. The digital medium is generally the internet.

Knowing that digital marketing can help you to grow your business won't solve the problem at hand. What you need is to learn how to engage in digital marketing. That is what this book offers. It will help you to be in the right position to market your business on all digital platforms, and potentially reaching thousands of new customers. This book focuses on the most effective form of digital marketing: social media marketing.

Are you confused on what platforms to use? How to create content? Or how to use paid adverts? This book will introduce all these aspects and more to you.

Digital marketing is one of the things I learned a little late. It was crucial to the growth of my business, but I didn't see the value in adding it to my marketing strategy before. I didn't put much faith in digital marketing.

I later regretted that decision when digital marketing became the focus in the business world. Other businesses seized the initiative and made excellent progress in reaching their customer base while I was left behind.

The truth is that in business, you are bound to make mistakes. I made mine, but I quickly found a way to correct them. I did my research, and I was eventually able to make steady progress.

My motivation during this period came when I tried out something new and immediately saw positive results.

I was loving everything that I was learning. In the years that followed, I kept at it. I worked as a consultant and helped many people get the most out of digital marketing. As an entrepreneur, this is another profitable income flow I have created.

Upon completion of this book, you should be at a level to start your digital marketing campaign. A significant benefit of learning digital marketing is the significant reduction you will enjoy seeing on your marketing expenses. Not to mention, the returns are that much better.

With the simple tips and tricks I have put together for this book, you will understand the importance of social media in your business. You will discover you have become more knowledgeable about content marketing, email marketing, and making use of some of the popular platforms in building your business.

It doesn't matter if you haven't worked on any digital marketing before reading this book.

If the growth of your business matters to you, then learning digital marketing can't be put on hold any longer. Fail to start now, and you may miss your opportunity to make a difference. This is a prime example of how procrastination can ruin both lives and businesses.

For anyone willing to grow their business to avoid regrets in the future, then you must follow the guidelines in this book. It is time to get down to business.

Prepare yourself for a journey to change the current state of your business for the better.

Chapter 1: Social Media Marketing

What is Social Media

Social media is a term that refers to the various web-based platforms, applications, and websites that support content creation and sharing by multiple participants. This results in a social network among the participants.

Social Media History

Social media, as a form of communication, is filled with a rich history that you must understand if you are to appreciate it. Since we are focusing on social media as a form of online communication, this goes as far back as the 1960s. The history of social media includes some of the platforms that paved the way for the likes of Facebook, Instagram, Twitter, and YouTube.

Every time I think of emails, my mind goes back to my younger days when I used letters to communicate with my grandparents. There was something that felt good about exchanging these hand-written notes. Nonetheless, these technological advancements made things much easier.

The ARPANET project in the 1960s can be said to be the foundation of the research that led to the development of the World Wide Web, or the beginning of URLs as we know them today. The earliest use of newsgroup posts, articles, and newsletters in virtual communication are traced back to the introduction of Usenet in 1979.

The development and release of GENie in 1985 saw the general public and businesses engage in the use of the online service in easing communications. As one of the earliest forms of social media, it had an estimated 350,000 users on its platform. Although GENie remained relevant until the 1990s, its success was short-lived.

Other platforms for communication that made their debut in the 1980s include Listserv in 1986 and Internet Relay Chats (IRC's) in 1988. Listserv provided an opportunity for individuals to send a single email to more than one user. This is a carbon copy (CC) feature on emails today.

It may not mean much now, but back in the 1980s, the CC feature was a huge deal. Another revolutionary development was the functions that IRC's offered to the users.

In addition to communicating and keeping in touch with friends and family, IRC's made it possible for users to share files and links. So many of the features that we mindlessly select nowadays weren't available 40 years ago. Can you imagine not being able to turn in your assignment through an email attachment?

To make chats more interesting, a unique program was introduced in 1994. This was known as The Palace. It featured chat rooms with graphical backdrops on which users would have their avatars. If users send any message in the room, it would appear in the form of a chat bubble.

To keep in line with the idea of a 'chatroom,' users had access to doors on the backdrops through which they could go to another room or move on to a different palace server.

Social media sites as we know today allow users to add a profile picture, make friends, and communicate with other users. These are the features that were available when Sixdegrees.com was released in 1997. It was the closest to what social media sites look like currently.

In the late 1990s, a unique social media site for activists was opened. This was the moveon.org website. As you move on (excuse the pun) through the years, you find out that the social media sites that you visit today give room for anything you need. These include politics, entertainment, activism, sports, and so much more. This wasn't always the case.

Considering how crucial blogs have become in providing information and reaching other internet users, blogging wasn't taken seriously when LiveJournal was launched in 1999. The platform offered users the opportunity to create and upload journals that others could see.

LunarStorm was another excellent social media site that was launched in 2000. It had an ads feature that made it unique from other social media sites.

If your business is benefitting largely from social media ads, then you can thank LunarStorm for being one of the first sites to implement the idea. The main reason why the platform implemented this approach was to use the funds generated from adverts in financing the site. I would say this experiment was successful considering the site ran for ten years before closing.

Inability to adapt to change can result in the fall of otherwise great companies. This was the case with Friendster. Although it remained functional for 13 years between 2002 to 2015, blaming the changes in the industry for the suspension of services isn't a sign of proper management. Don't let your business be like Friendster.

The year 2003 was a great year for social media. It saw the launch of some of the best social media platforms. LinkedIn, MMOs, MySpace, WordPress, and various photo-sharing platforms like Flickr and Photobucket were introduced in 2003.

Each of these platforms was unique in their operations, and these made them stand out at the time. MMOs like SecondLife are a form of social networking, and that is why I mentioned it on this list. Players get to create a character, and have fun together while interacting virtually.

Unless your business offers rare virtual equipment to players, I don't think you will find much success opening an account on MMO games. Before its actual launch in 2006, an early version of Facebook was released in 2004. This was in addition to other sites like Hyves, Orkut, and Piczo that launched in the same year.

One of the few sites that you can consider the king of social media (how else do you refer to a website that ranks as the second largest search engine?) was launched in 2005. If you couldn't guess it, I am even more glad I included the history of social media in this book. Yes, I am talking about YouTube.

Its unique selling point at the time was the option to share video content all over the world for free. The keyword here is 'free,' and nothing beats that. Reddit was also released in 2005. In 2006, something spectacular began to happen.

Yes, this was the year the Facebook as you know it entered the social media game, and ultimately changed it. If you look at the current stats as well as the historical growth of Facebook, it is remarkable. It remains one of the most popular social media platforms in the world, and I'm not wrong when I say it took over.

Many people tend to forget that in 2006, Twitter was also launched. Why did it stand out? Simple, users could establish direct communication with celebrities on the platform. Can you imagine having an interaction with your favorite celebrity? Although it doesn't compare to having a shirt autographed by Beyoncé, users were having fun reading tweets from some of their favorites.

If you are an expert at microblogging, then you must have an idea on how to use Tumblr. The site was launched in 2007 and currently boasts of over 475 million blogs.

In 2008, the social media platforms that came into being include Kontain, Groupon, Spotify, and Ping while Foursquare was launched in 2009. The check-in feature of Foursquare was something unique that made it stand-out.

Instagram and Pinterest, two social media platforms that now rank at the top launched in 2010. That's an interesting coincidence considering Facebook and Twitter were also launched together in 2006. These four platforms are on the list of top 20 social media sites according to the number of users. This ranking is based on information from Statista.

Many users still remember the shut down of the Google+ platform. It was released in 2011 and allowed users to use the hangouts and circles features to ease communication. Well, we all moved on fast after its shutdown.

Another popular social media network that has left the building is Vine. It was a platform created by Twitter that allowed users to share videos of 6-seconds in length. That's the length of most YouTube short adverts.

Current Changes in Social Media

Since becoming mainstream, it has become essential for social media platforms to offer the various features that users need to remain competitive. To meet this demand, several social media sites currently enable users to engage in live broadcasts in addition to sharing voice notes, audio, text, and audio content.

Take Facebook, Twitter, and Instagram, for example, they didn't always have a live broadcast feature. They are changing to keep up with user needs. Adaptability is a crucial proponent for success in your business.

The current framework of the social media platform was developed over these long years. The impact of history are the benefits that businesses and individuals can enjoy from social media platforms today.

Cross-platform content sharing is one of these features that remains a huge benefit for your business. All these improvements and there is only one thing that has remained the same over the years. This is the excellent opportunity social media platforms offer for users to interact with one another.

The Future

When looking back at history, it is crucial you also consider the future. What does the future of social media hold for businesses and individuals alike? This is a question everyone is trying to answer.

There is one thing that is certain; social media platforms are here to stay. Why? We all crave the social interaction we get on social media. While it is preferable to get out of the house and live life, you won't always be close to the ones you love and want to communicate with.

Social media connects people from various walks of life. This includes connecting your business to its customers.

Importance of Social Media Marketing

What is Social Media Marketing?

Social media marketing is a process that incorporates the use of social media platforms to engage in actions that drive brand and business growth. These actions revolve around interacting with your target audience and engaging with customers. The results of these actions include a boost in traffic to a business website, as well as an increase in brand sales, and improved brand recognition.

The following are some of the actions that promote the growth of a business on social media:

- Actions like posting content on social media

- Engaging in a social media advertisement campaign

- Replying comments from customers

- Data analysis

Most of these actions can be achieved with ease on the social media site, but the data analysis aspect of social media marketing often requires an additional tool. Other tools can also help to improve the effectiveness of different marketing actions.

Why Must Your Business Engage in Social Media Marketing?

There are some simple and straightforward reasons why your business must engage in social media marketing. One of these reasons is to hear about your business from others. The truth about your business can only become more evident when you listen to those that have experienced its services.

Social media is a place where most of your customers go to voice out your opinions and to get these opinions, and you must be on the social media platform. Another reason is to reach your audience with ease. This involves the use of targeted social media ads.

If you have had the experience of traditional advertising, you know that these adverts often involve paying for space on the local newspaper or distributing flyers. But how far can you go with your flyers? How many individuals still take time to read local newspapers?

Essential Areas of Social Media Marketing

When engaging in social media marketing, five areas are vital to the success of the campaign. These areas will be discussed in this section.

Marketing Strategy

The fundamental step of social media marketing is a marketing strategy. Your strategy requires you to think thoroughly about what your business expects from the campaign and how it intends to achieve it. There are specific questions that you must answer when developing your strategy.

What are the objectives of the campaign?

A marketing campaign requires several objectives that it should help the business achieve. These objectives are essential in assessing the performance of the various marketing actions of the company.

As a business, one of the objectives you can set for your campaign is to boost traffic to your website. Another is to develop a community for the company. The goal can also be to increase the level of engagement your business is getting online.

Other things, like creating a channel for comfortable customer support and promoting brand awareness, also make excellent objectives for your campaign.

What type of content should the business share?

The target audience of your business determines the type of content that you will use. What kind of content quickly gets a person's attention? Answering this question can tell you what you need to know.

The content that your audience needs can be entertaining or educational. Educational content must provide useful information while entertaining content should be compelling and amusing. Do they prefer content in video format or images? Or are you targeting those that will click through a link?

It is during this process that it becomes crucial to come up with a persona for your customer. If you try it out the first time, you can make changes to the persona depending on the performance of the campaign.

Is there a social media platform for your audience?

Being on multiple platforms is necessary, but you can't be on all of them. It is crucial you determine the platforms that your target audience frequently use when coming up with your strategy. These are the platforms that you will focus on for your social media marketing campaign.

In addition to the leading platforms, others like Tik Tok, WhatsApp, Messenger, and Tumblr can be beneficial to your business.

Social Media Advertising

The goal of social media marketing is to reach your target audience with ease. In most cases, we want to gain this reach without having to spend too much money. As a business, you must be willing to contribute to reap the benefits of social media marketing.

One benefit of advertising on social media is that it doesn't cost as much as traditional adverts. Despite this low price point, social media ads have proven to be the best in the business. How?

The option to create targeted ads is the main reason. This means that you can set up a few requirements that an individual must meet before they can see your ad. This is who your ideal customer is.

This includes behaviors, demographics, interests, and so on. Social media advertising allows you to optimize your marketing campaign for a greater success.

Content Publishing and Planning

Content publishing refers to the process of sharing or uploading images, videos, or blog posts on a social media channel. To make the most of content publishing, you need to post frequently on these channels. With so many users present on each social media platform, it will be challenging to get your content in front of all the members of your target audience.

To make sure you post consistently at the same time every day or week, implementing a schedule is essential. This schedule is your plan for content publishing. There are numerous tools online that simplify the process of scheduling your content.

With these tools, you can automatically post content on various social media platforms. To make this work, you must create your content beforehand. This step allows you to carry on with your daily activities without forgetting to upload your content at the right time for your audience to see.

Timing and frequency of posts count with social media marketing.

Engaging and Listening to Your Audience

Social media marketing is directed at promoting brand awareness. To do this, you should get your audience to follow your social media accounts. When this happens, you start getting people that send direct messages, comment on your content, share the content and tag you in other posts.

Conversations about your brand steadily increase due to the presence you have established. Some users tag the brand in these conversations while others don't. It is not compulsory for users to tag the brand.

For the success of your social media marketing, listening to every bit of information about your brand is crucial. You will find positive comments about your business but also get ready for the negatives. Your goal, when you see negative feedback, is to try to contain the situation before it gets out of hand.

The things you can do include finding out the reason for the negative comments and providing support to fix the problem. That said, it is not always easy to fix such situations. For the positive comments, thanking the user goes a long way.

Using any of the social media listening and engagement tools available online, you can keep track of every conversation related to your business. Most social media platforms provide notifications if anyone tags your business. The online tool is essential in finding those that didn't tag your business but are discussing it.

Social Media Analytics

The final area of your social media marketing that is crucial is analytics. This is a look at the performance of your social media marketing campaign. There are several metrics you can assess when using social media analytics.

How many mentions did your business receive? How did your audience engage with your last post? How many users saw the previous post? How many clicks did you get on your link?

These are some questions that analytics can answer. Google Analytics is one of the powerful analytics tools that you can get online. And it's free to use.

Social Media Trends for the Years 2019-2020

A Shift in Focus Towards Micro-Influencers and Nano-Influencers

Influencers are essential accounts on social media channels. These are the users that have many followers on a social platform. When considering the number of followers in descending order, influencers fall into mega, macro, micro, and nano influencers.

This ranking means that mega-influencers and macro-influencers have the highest number of followers. This may seem like the best option for your brand, but the trend is steadily changing with micro-influencers and nano-influencers becoming more critical.

These influencers have been discovered to have more influence on their followers than the mega and macro-influencers. They gain the loyalty of their followers through their ability to exhibit knowledge on a topic of interest.

These influencers' lead can get your business to have the possibility of quick progress.

The Rise of a New Social Network

With the boost in popularity of Tik Tok, there is a significant issue that brands must solve if they intend to reach users on the platform. Twitter boasts 126 million daily active users, which is just 6 million more than the 120 million daily active users Tik Tok has in India. The platform also has 150 million active users in China.

All content on the platform is user-generated, which makes it difficult for brands to fit in on the platform easily. With costs of brand takeover ads having a $50,000 minimum, it will be difficult for small businesses.

Chapter 2: Content Statistics

Why Use Social Media for Your Brand

It Boosts Traffic to Your Site

When trying to get more visitors to your website, using social media is an excellent tool in achieving this goal. The content you post on your social media profiles goes a long way in achieving these goals. Social media users love content with value, and this promotes engagement.

If you can get users to engage with your content, then you can redirect them back to your site when you see an opportunity. Social media allows you to add clickable links that make the process much more convenient.

It Provides Access to Your Target Audience

In recent times, the growth of social media has resulted in the creation of several platforms. Facebook, Twitter, Instagram, YouTube, Snapchat, Pinterest, and many more. Regardless of the number of social platforms present, each of these platforms remains relevant.

It is easy to conclude that you don't need to open an account on more than a single platform if you don't know what the others offer. The fact is that each social media platform offers distinct features that separate it from the rest. While Instagram encourages users to document their life using pictures, Twitter is a platform that helps users to share ideas in a tweet.

Since there are differences in what each platform offers, each platform also has a demographic that is appeals to. If you are out in search of more female users, then using Pinterest is a suitable option. Snapchat is a great platform to reach the younger audience while LinkedIn provides access to professionals.

What this means is that for each social media platform, there is a specific audience that you can reach. Identifying your target audience will help in determining the social media channel that will be best for your marketing campaign.

Boost Your Rankings on Search Engines

The only way I can put this is that search engines love social media channels. Depending on your SEO efforts, keywords in your content can get you in front of your target with ease. Also, the engagement on your social media accounts influence these results.

High engagement helps in enhancing the social media presence of your business. If you have a significant social media presence, it is usually an indication that you are trusted, reliable, and credible. Try typing in the name of any popular company in your Google search box.

Can't decide on a company? Try Microsoft or Nike. Due to their presence on Twitter, you notice that in addition to the company website and Wikipedia page, their Twitter accounts will appear among the top three results.

For another example, try Apple and Apple Music. For the former, there is no Twitter result without adding twitter in the search engine, while the latter's second result is to their Twitter. A quick look at the Twitter profile of Apple (@Apple) and that of Apple Music (@AppleMusic) will give you the reason for this.

The Apple Music profile has numerous posts that users can engage with, and this enhances its social media presence. This is the type of benefit your business can get from an active social media profile.

For Business Research

With the option to perform polls and surveys, you can get your customers to give their opinions. You may request for their verdict on an existing product, your service, or a product you intend to release in the future. This can help in making the right decisions.

Considering that other businesses will also be present on social media, you can also gather information on their strategies.

It Reduces Your Business Advertising Expenses

Unlike traditional methods of advertising, social media marketing is free. Regardless, it is usually necessary to engage in paid advertising on social media. Despite this, the cost is lower in comparison to traditional advertising.

The goal of a traditional advert is to improve brand awareness by getting individuals to recognize your brand logo and tagline. With your social media accounts, setting your logo as the profile picture helps in achieving the same goal. As users engage with your content by commenting and sharing, your brand logo becomes visible to more users around the world.

The cost of reaching all corners of the world is much less than what you would spend if you must book a spot on the Super Bowl halftime show.

Search Engine Optimization

Search Engine Optimization refers to various actions that you can perform to improve the ranking of your website or blog in search results. These include results from the various search engines like Yahoo, Google, and Bing.

The Search Engine Ranking Factors (SERF) are the algorithms that determine the position of a website on the search engine results. There are three stages that you work on when performing SEO practices.

Technical SEO

These are the configurations you make to the various settings of a website. Correct configuration of these settings will enhance the functionality of search engine crawlers on the site.

On-Site SEO

The focus of the on-page SEO is the content of the page and the various elements present. This is the part of the SEO that makes the content of your website meaningful to the search engine crawlers. They provide signals to the search engine crawlers to achieve this objective.

It is through the on-site SEO that you offer improvements in the user experience of the website. The on-page SEO requires you to act on areas like the title optimizations, internal links, website structure, headings, structured markup data, image SEO, SEO keywords, and more.

Off-Page SEO

This is the final stage of the process. Backlinks or incoming links are one of the factors that search engines use in ranking a website on the search results.

Since these links are from other sites, they indicate that your website can be trusted.

The influence of a backlink on the ranking also depends on the reputation of the site providing the backlink. The backlinks have to be genuine since Google places a penalty on a website that uses link farms, paid links, and other unethical means in obtaining the backlinks.

Why Do You Need SEO for Your Brand?

As a brand, there are lots of other companies that operate in the same industry. This means that you will be competing for customers. When a customer decides to search for a company in your specific type to solve a problem, the first place they try is on a search engine.

Once they type in the industry, the search result produces a list of businesses that operate in that industry.

As a business in this chosen industry, what is the assurance that your blog or website will appear in the search results?

This is a situation in which SEO is vital. For a better understanding of why you need SEO for your brand, read on:

Enhanced User Experience

Through SEO practices, your website becomes easy to navigate and improves the user experience. The actions you take during the SEO process like improving the load speed of pages and site responsiveness become noticeable when visitors navigate through your website.

It Grows Your Brand

The growth of your brand depends on various areas like conversions, customer retention, and sales. Once you can stay ahead of your competitors on the search result rankings, these goals become easier to achieve. Through excellent SEO practices, you can make more sales through your website than a competitor offering the same products but with poor SEO.

Better Visibility

Your actions towards SEO usually pay off by promoting the visibility of your brand. Since your website can rank higher on the search results, it makes it easy for people to find your business.

Increased Traffic

When people search for anything online, there results on the first page usually provide all the information they need. If you can get your website to rank on the first page, you will notice an increase in the traffic your site is getting.

What is a Brand?

A brand is how your business appears in the eyes of the customer. It can refer to any quality or characteristic that someone can attach to your business. Your logo, website, product packaging, customer service, and storefront are some of the features that define your brand.

Your brand can also be defined as the reputation of your business. The benefit of having a brand that stands out is consistent growth. This growth can result from a boost in your business marketing through word-of-mouth referrals. When your customers believe in your brand, they are willing to introduce your products to friends and family.

Brand Building

Building a brand requires investing a lot of time. It is not something that happens overnight. Look at some of the most popular companies today. You can attribute their growth to the consistency in the services they offer and the uniqueness of their products over the years. Think companies like Microsoft, Amazon, and Apple.

Comparing Microsoft and Apple, despite both companies being technology companies, they still stand out. This is because each company has built a brand around the unique products they offer to their customers. In the process of brand building, your objective is to develop various campaigns and strategies to boost your marketing efforts.

These campaigns can include the following:

- Social Media Marketing

- Paid Adverts

- Content and SEO Marketing

- Email Marketing

Building Your Core Brand Strategy

What is a Brand Strategy?

A brand strategy is a plan that contains information on the goals your business intends to achieve through the process of brand building. One of the essential qualities of a branding strategy is that it must focus on long-term goals. A brand strategy that focuses on short term goals is a recipe for disaster.

The reason for the focus on the long term is that a brand requires a long time to be built. During this period, the brand strategy in place must support the sustainable growth of the brand. Flexibility is another essential feature of a brand strategy.

The brand strategy should be competent in taking advantage of short-term goals that can promote brand growth.

Tips for Building a Successful Brand Strategy

Identify the Purpose of the Brand

Your brand purpose and mission go together. The mission is simply a statement of the purpose of your brand, and it is crucial.

Your brand purpose is one of the things that attract customers to your brand. It connects people with like minds together. So, what is a brand purpose?

The brand purpose is a statement that outlines the change your brand wants to create. This change focuses on the outside. This means that the goal is that the brand wants to see a change in the world. The first step in identifying the purpose of your brand is to determine what the brand wants to change.

After that, there must be a clear definition of the unique actions the brand can take to bring about this change. To sell this purpose, there should be an outline of the benefits this change will provide for customers, employees, and everyone else.

The final step is to get everyone that is connected to the brand to buy into the purpose. Your brand, customers, and employees must work towards making this purpose become a reality.

Define Your Target Audience

Your brand strategy will thrive when you have a clear definition of who your brand will serve. Your inability to determine your target audience will hinder the brands' effectiveness due to lack of focus. A target audience enables you to develop a strategy that will be effective in promoting the brand.

In defining your target audience, there are a few questions to answer. These include the following:

- What age range is your target audience?

- What is the occupation of individuals in the audience?

- What tone is suitable for speaking with them?

- Their Gender

- Education

- Income

- Location

Using these factors to determine your target audience is crucial in growing your brand. You can provide high-quality products that are well-within the purchasing power of your audience if you can identify the income level with ease.

A target audience is essential in getting ahead of your competitors. Through this action, you can tailor your content to meet the needs of your customers. This enhances the clarity of your messages and promotes ad clicks.

Study Other Brands Within the Industry

As a brand, you are going to have competition in the industry. These are other brands that are experiencing success by attracting new customers and delivering excellent services. When studying your competitors, you must not copy what they do.

Nonetheless, you must know the areas where they fail and the things they do well. The information you get from this study will help in building a brand that is different from the others. Achieving this objective is vital if you want to influence a customer to pick your brand over your competitors.

In studying these competitors, you must develop a spreadsheet if you intend to simplify the process. If you don't want to stick to the traditional method of using a notebook, then Excel and Google Sheets are excellent tools for building the spreadsheet. So, what will you analyze using the spreadsheet, and how do you go about it?

The following are some of the vital aspects you must pay attention to and steps to take during the analysis:

1. Identify and list out your competitors on the spreadsheet.

2. Describe the business operations of each competitor.

3. Determine their target audience. To do this, identify the age, gender, and income level of customers.

4. List the prices of the products that these competitors offer and assess the quality.

5. Analyze the marketing strategy of these brands. For an in-depth analysis, you may need to follow their social media platforms, sign up for email newsletters, and so on to get a look at their content.

6. What are the features that make these competitors unique?

7. Determine the strengths and weaknesses of each competitor.

To ease the assessment process, you can limit the number of competitors to four. After the assessment, you can learn the differences between each competitor, their marketing strategies, brand visuals, and many more. Remember, you must not make the mistake of copying anything from other brands.

Identify What Makes Your Brand Unique

After the analysis of your competitors, it is time to look inwards. This is when you determine what makes your brand different from your competitors. These features are your selling point and what you capitalize on during your marketing campaign.

If your competitors are brands that use traditional methods in their operations, then adopt the use of technology to reach the younger demographic. If these brands offer products at a higher price, then can you provide the same quality of products at a lower price point? Is your customer service better?

These are all benefits that customers can get from your brand, and you must outline these benefits when building your strategy.

Develop a Personality for the Brand

As humans, everyone is unique. This is due to our differences in personalities. When you start thinking of your brand as a person, it becomes easier to come up with unique characteristics that will make it stand out.

The personality of your brand encompasses various aspects such as its values, purpose, and beliefs.

There are areas where the brand personality applies. These are the areas you need to focus on when developing the right brand personality.

Develop a Tagline and Logo for the Brand

The brand tagline and logo are crucial parts in developing a personality for the brand. The logo is the visual appearance of the brand. You can think of it as the face of your brand.

Unlike other parts of the brand-building process, you will need the help of an expert in developing your brand logo. Why do you need to go that far? This is because the face of the brand must be visible on anything associated with the brand.

You want the logo of your brand to stand out wherever it appears. To do this, you need to source for someone with experience. You should know that this will cost a substantial amount of money, but if you get something extraordinary, it will be worth the cost.

There is another reason why you need a professional at this point. This is to help to create guidelines for the use of the logo. These are not guidelines limiting the application, but to assist in ensuring that you find it easy to use the logo effectively in the future.

The guidelines consist of information regarding the following:

- Iconography

- Web elements

- Logo size and placement

- Typography

- Fonts

- Image style

- Color palette

Going with the logo, you also need to come up with a tagline. This is the catchphrase or slogan that your brand will use. Your tagline should be something that will immediately get your customers to remember your brand when they hear it.

An example of an excellent tagline is "Just Do It." Anyone that hears this tagline immediately remembers the Nike brand.

Add a voice

A brand voice is the easiest way to connect with your customers. This is when you choose a tone in communicating with your target audience. The response you get from your customers depends on the voice you use in communicating with them.

What brand voice will get you on the same wavelength with your clients? When reaching out to customers on LinkedIn, using a professional brand voice can be beneficial.

Using the same voice on a platform like Facebook won't yield positive results. Some of the examples of brand voice you can use are:

- Conversational

- Professional

- Informative

- Technical

- Friendly

- Promotional

- Authoritative

Your brand voice is what you use in creating content for your social media posts and blog posts. Once you pick a brand voice, your audience will be expecting the same voice across the various channels where you communicate. Select the right brand voice based on the industry of your business, the business mission, and the target audience.

Content Marketing

What Is Content Marketing?

As an internet user, there are various social media platforms that I visit daily. Over the years, I have come across several ads while using social media. Most of these ads offer nothing of value to me, so I overlook most ads.

This is the truth for most of us. With the internet getting saturated with ads from marketers trying to reach their audience, we have developed a subconscious ability to ignore these ads. If adverts are not as effective in reaching your target audience like in the past, then how can you get them to notice your business?

Content marketing is the answer to this question. It is a marketing technique in which you create content that is relevant, valuable, and unique. Relevant content is one that meets the needs of your target audience. It is unique if the audience can't find anything like it on other platforms.

Your audience will tag content as valuable if they can find information that is useful and educational. Unlike advertisements, content marketing focuses on improving the lives of your audience. It is more than just finding a way to sell your products and services to the audience.

Through content marketing, a business can develop a positive relationship with customers, which can help in boosting engagement. There are various forms of content marketing, and they include the following:

- Email newsletters

- eBooks

- Social media posts

- YouTube videos

- Instagram posts

- Webinars

- Podcasts

Why Do You Need Content Marketing?

Content marketing has several benefits for your business. It is an essential aspect of growing your business. It is also crucial you engage in content marketing if you want to run digital marketing campaigns with excellent performance.

There are other reasons you need content marketing. Read on to find out more.

To Promote Conversions

A significant reason why content marketing is necessary is the ease with which you can enhance your conversion rates. Conversion is all about getting users to request for additional information, make a purchase, or reach out to your business. With content marketing, you can enable users to make the right decision by providing the necessary information.

Through content marketing, you use your content to state the next step the prospect should take clearly. This can be with call-to-actions in the content.

To Establish Expertise

In every industry, the consumers always listen to those that they see as the experts on a subject matter. So how do you make your business one of these experts? The simple way to do this is through content marketing.

Publishing whitepapers, blog posts, and posting content on social media are some simple ways to offer information online. When your prospects get to read your content, you can show how knowledgeable you are on the subject matter. If you consistently post content that offers value and crucial information in solving a problem, these prospects begin to hold your business in high regard.

They have the belief that if there is any other issue to be solved or question to be answered in future, they can rely on your business. As a result of these beliefs, these customers will quickly turn to your business when they want to make a purchase.

It Makes Your Business Unique

As a business, you will have competitors in the industry that you need to get ahead of. In most cases, the differences between you and most of these competitors are minimal. This is the reason you must work to find something to serve as a critical differentiator.

You may have some products that can solve the problem of a customer, but if they don't know this, they won't have a reason to buy these products. You can use your content to inform customers of these products. You can indicate the issues they are facing and then give them specifics on how your product can help.

Making your business unique is also possible through a brand personality. You brand voice and content presentation are vital in making your business stand out.

Good Content is Essential for the Success of Other Marketing Strategies

It doesn't matter if your overall strategy includes social media marketing, email marketing, and paid adverts. All of these strategies require great content to be successful. Creating the right content can help in nurturing your leads and driving them through each stage of the sales funnel.

In the first step of the funnel, prospects are looking for solutions to a problem that they are currently experiencing. With your content, you can provide information on the various available solutions and those that can help to solve the problem. The middle of the funnel is where you create content that allows customers to filter their options.

Your content will help them in assessing each solution or product to remove the least helpful. At the bottom of the funnel, your content works towards making conversions. The content should be able to give the final push in the right direction.

The goal of email marketing, social media marketing, and paid adverts is to get your customers through this funnel with ease.

Determining the Type of Content to Create

Make Use of Analytics

The analytics feature is available to help you in deciding the right content to create. There are several metrics that you can use as a determining factor. If you have connected your analytics tools to the platforms on which you communicate with your audience, then open the respective tool for each platform.

On the respective analytics tool for each platform, you can find the posts with the highest engagement. These are often listed as top posts. Then you ask yourself a few questions:

- Is the content type the same? This is to determine if your audience show more interest in videos, audios, or texts

- Are topics similar?

- What were the comments on the posts like?

- Did you repurpose the content from another format?

When you find similarities, you can determine the type of content your audience want.

Get the Audience Opinion

If you are not fit for the process of guessing, then you can throw the question to the audience. There are several ways to do this. Using emails to reach out to members on your email list is suitable when you want to get the opinion of your blog readers for your next blog post.

For the times you have a few topics in mind, you can set up a poll on platforms like Instagram and Twitter and let the audience select their choice. The topic with the highest percentage is what you create.

In a situation where you can't come up with anything, then you can ask a question instead. Your audience can reply using comments.

Assess Other Businesses in Your Industry

There are times when the content from your competitors and other businesses in your industry can give you an inspiration for your next content. You can check for their top-performing content to know what their audience loved. Since their business is in the same industry, the behavior of their audience will be similar to yours.

Your goal is to learn from what they are doing and not to copy. You can cover areas of a topic that they didn't include in their content. You can swiftly get this information if you go on Facebook.

Facebook offers Pages to Watch feature that provides information on the top posts of pages that are closely related to yours.

Weigh-In on Trending Topics

Trending topics allow you to give your opinion on something that everyone is talking about. These topics only last a short time so you must provide your opinion as soon as possible. On Twitter, these are the keywords that are usually followed by the hashtag.

The main benefit of trending topics is that it allows your audience to give their opinion on the subject. It is one of the best ways to generate engagement on your profile. There are some controversial topics that you shouldn't discuss on your business profile, such as anything relating to politics.

Chapter 3: The Main Social Media Feeds

Facebook Marketing

Why Engage in Facebook Marketing?

The Number of Users

Since its launch in 2004, Facebook has remained relevant as a social media platform. In its 2019 results announcement for the second quarter, the company recorded more than 2.41 billion monthly active users with an average daily login of 1.59 billion users. That's a considerable number of users.

If you know what you want for your business, then you understand the opportunities that are available with these numbers. Promoting your content on Facebook offers the possibility of reaching many of your target audience on a single platform.

To Promote Interactions with Customers

Getting customers to like, comment, and share content is a form of engagement. Facebook groups create a forum that supports discussions between various users and your business.

As a social media platform, it is a two-way engagement that allows users to voice their opinions and get a response from the company.

For Free Promotion

Promoting content on Facebook is easy – if your content has the right qualities. Meaning it is engaging, informative, and offers value is something that all users on Facebook love. The most important aspect is getting users to share the content.

When members of your business group or followers of your page start sharing your content, it can enhance your brand visibility. With your logo as the profile picture of the page, it also increases brand awareness. This is just a little bit of the free promotion that you get with Facebook marketing.

To Resolve Issues Your Customers are Facing

Businesses thrive when they can solve the problems that customers face. Some of these problems can be solved using the products that the company offers to the customers. In other cases, the solution to these problems requires tips, insights, and expertise of the business.

Facebook allows customers to communicate directly with a business through discussions on the group. By posting a question on the group, they can let the company know any issues they are currently facing. As a business, it is also your job to answer questions on these groups in a timely fashion.

Developing Your Business Presence on Facebook

Open a Facebook Business Page

Pages on Facebook is a vital tool in building brand presence. One of the essential features of the Facebook Page is the Insights. Setting up a Facebook Page can be done in the following steps:

Create the Page

The Facebook Business page requires a Facebook account to be created. On your Facebook home page, you can find the Pages option on the left side of the screen. This opens that Pages screen on which you must click on the 'Create' button on the top navigation bar and select page.

This will take you to a new page where you will pick from two options:

- Business or Brand

- Community or Public Figure

Select 'Business' or 'Brand' and click on the "get started" button.

Add Business Details

The platform requires certain information to complete the profile. These include:

- Business Name

- Category

- Address

- City and State

- Zip Code

- Phone Number

You can decide to hide the address of the business and only display the city. Once done click on the continue button.

Add Images

These include the profile picture and cover image of the Facebook Page. To boost your brand awareness and recognition, use your logo for the profile picture. The cover photo is your choice to make but be sure to use one that depicts the nature of your business.

Add Other Information

The page allows users to add a short description which you can use in letting other users know what your business is about. This description is visible on search results, so it is essential if you want to attract new customers. There is an option to add a website to this page.

Use this in directing traffic to the official site of your business. To make the page easy to find, you can add a username to the page. Be sure to use one that is easy to remember.

The Facebook page allows users to follow it and like the content on the page. There is no limit to the number of followers on a page and users that will get to see the content you post. It can be challenging to promote engagement with Facebook pages, so you must set up a Facebook group.

Use Facebook Groups

Building a Facebook group is straightforward. You can create the group to be an extension of your Facebook page. A Facebook group is an excellent place to start developing a community for your customers.

The unique aspect of the group is that it promotes discussions among the members. The groups require more time investment if you want to see it grow. As a community, there will be many users posting questions and ongoing discussions that require your input.

You must remain active on the Facebook group to enable it to grow and manage the members that join. You don't want anyone to destroy what you have built.

Interact Regularly with Your Customers

Being active on Facebook doesn't mean you are always posting content that pertains to the services or products you offer. Getting other users interested in your products and making purchases may be the goal of your campaign, but you shouldn't be aggressive in your marketing.

A better way to promote the brand is to interact with other users on the platform. This involves posting content that offers value. These contents will get users to share, like, and comment, which are the primary forms of engagement on Facebook.

You can promote this engagement by including questions in your posts. Users will comment when they feel you are creating your content while considering what they have to say. If you want to offer other forms of engagement, try any of the following options:

- Set up quizzes and polls

- Create posts that require users to fill in the blank spaces

- Host contests

- Ask users to caption a post

If you are expecting your audience to make the first move, then you won't make any progress in your marketing campaign. A user might like your high-quality content, but this doesn't mean that the user sees the need to comment.

Post at the Right Time

The news feed of every user on Facebook is dynamic. There are usually several new posts within a short time. This means that it is possible to post content that some members of your audience won't get to see.

If you want to get your content across to your audience, then you must know the right time to upload a new post. The worst time to post is during work hours and when everyone is sure to be asleep. So, when is the right time to post?

Having the right data is always your best option when figuring out the best time for posting on Facebook. A Facebook page can help in getting this data. This is through the Insights available on the page.

There is an 'Insight' button at the top of the Facebook page that you can click on to start. This takes you to the dashboard of Facebook Insights. The insights section allows you to assess several metrics to aid you in your marketing campaign.

The menu on the left on the insights dashboard provides access to different areas, including the 'Posts' option that you need for this process. When you click on it, these options are shown:

- When your fans are online

- Post types

- Top posts from pages you watch

Select the "when your fans are online" tab to find the data you need. This displays a chart and a breakdown of user activity over the past week. The graph plots the average of the information while clicking on any day will plot another line on the chart.

Below the chart, you can also find the information on all the posts you have published on Facebook. There is an "All Posts Published" button that takes you to this area. The information on this screen is split into seven columns, namely:

- Published: This column shows the date and time you posted the content

- Post: This is an image and a brief intro of the post

- Type: What format? Text or Video?

- Targeting

- Reach: This indicates organic and paid reach

- Engagement: This shows the clicks on the post, comments, shares, and likes

- Promote

Comparing the information on this section, you can find out the content that performed best, and the time you posted the content. This can work as a guide in determining the best time to promote in the future.

Whatever you decide after carefully considering the data needs to be tested. Try it out when posting your next content. Is there any improvement in the engagement?

Using Facebook Ads

Facebook ads are paid adverts that enable you to reach many members of your target audience. Considering the number of active users on Facebook, it will be impossible to get your content in front of most of these users without any help.

The Ads Manager is your key to Facebook Ads. If you click on the "Advertising on Facebook" option that is present in the drop-down menu when you click on the downward pointing arrow on the top right of the screen. On the page that follows, click on the "Create an Ad" button to go to the Ads Manager dashboard. From this dashboard, you can start creating the ad.

Select the Objective of the Ad

The first thing Facebook requests is the objective of the ad. There are three classifications of the objectives. These are awareness, consideration, and conversion objectives.

There is a further breakdown that results in 11 distinct objectives, including:

- Brand awareness

- Traffic

- Catalog sales

- App installs

- Reach

- Engagement

- Video views

- Lead generation

- Conversions

- Store traffic

- Messages

Define Your Target Audience

To improve the performance of your ads, Facebook offers targeting options. The options that it provides include the following:

- Gender

- Education

- Interests

- Location

- Languages

- Generation

- Age

- Work

These are just a few of the available options. These options are accompanied by an audience definition gauge tool. What this does is to indicate the potential reach of your ad using the features you select.

If these targeting options don't meet your needs, then you can choose a custom audience on Facebook. These are people that may be using your app, interacting with your website, or those whose details are available on your business database.

Choose a Budget

For convenience, there are two options for the Facebook Budget. These are the daily and lifetime budget options. The daily budget is suitable for ads that you want to run all through a day while the lifetime budget is for those that you need to run over a period.

Create a Schedule

How do you want the ad to run? Do you have a start date for the end? When do you want it to end?

You can also set the time during the day when the ad will run on the platform.

Start Creating the Ad

After adding the general ad settings, it is time to create the ad. This is how the ad will look when it appears to your target audience. The ad format is the first part you select in this case.

These formats include the links and carousels. Links refer to a single image ad while carousels allow the inclusion of multiple images. Once you decide, you can start completing other sections.

For each format, there are guidelines and limits on the text, headline, image resolution, image ratio, and link description. Texts are restricted to a maximum of 20% of the image.

The ad formats that appear may differ based on the objectives you choose for the Facebook Ad.

Tracking Ads Performance

This is how you determine the success of your ads. It is common for individuals to have separate marketing software to track the performance of their ads on various social media platforms. The Facebook Ads Manager can help in assessing this performance.

To get a precise analysis of the performance of your ads, there are some key metrics that you should track. These include the following:

- Engagement

- Click-through-rate

- Event

- Cost per event response

- Reach

- Impressions

- Video views

- App installs

Things to Avoid When Creating a Facebook Ad

Creating a Facebook ad can be very easy. This means you have opportunities to make costly mistakes during the process. To ensure your ad is accepted, here are some things you should avoid:

Grammatical Errors

Various points relate to this heading. These include the:

- Sentence structure

- Capitalization

- Spelling

- Punctuation

Capitalization is something you must pay attention to. When trying to get the attention of your audience, it can be tempting to capitalize on a single word or a complete sentence.

Capitalization results in incorrect grammar and makes your ad seem like spam.

You are trying to build a brand; hence, you must appear professional. Your sentence structures are crucial in creating this appearance. Your clauses, nouns, and verbs should all be grammatically correct.

Spellings and punctuation are other areas that you must carefully consider when creating your ads. Some brands create ads using slang or incorrect spelling. Slang will usually only make the cut if it appeals to your audience and you use it smartly.

Using symbols or numbers to replace certain words can also get your ads rejected. Having someone to proofread can help avoid grammatical errors in your advertisements.

Twitter

Are There Reasons Why You Should Tweet?

As a social media platform, getting followers on Twitter can be a difficult task. When you have no followers, you may decide not to post anything using your account. The main reason for this is the presence of the like and "retweet" button on each post,

With these buttons available, you can easily see the number of users that click on each button. This means you can evaluate the performance of your tweets on the go. It can be challenging to keep tweeting when you know that you are not getting any engagement on your tweets.

Nonetheless, there are still some important reasons why you should tweet. Some of these reasons are discussed below:

You can Perform Free Marketing on Twitter

Although you can, you don't have to pay for ads to successfully market your business on Twitter. If you get the hang of it, you can boost your brand awareness and promote word-of-mouth through the platform. This is possible because Twitter offers the opportunity for smooth interaction between customers and businesses.

With this possibility of interaction, you can help solve problems that your existing customers have, and connect with new customers. You can also promote products and services in your tweets. All these are available at no cost.

You Can Keep an Eye on Your Competitors

In business, you must stay informed. Maintaining your Twitter account offers you the opportunity to monitor what your customers are doing on the platform. Unless they are discussing using Direct Messages, which is unlikely, you can read through the interactions between your competitors and customers.

With the ease of the process, you can take note of things you can adopt and those you should avoid for a successful Twitter marketing campaign.

Easy Targeting

Twitter is a platform that is open in terms of the users' information, their interests, and other crucial details that can aid in customer identification and targeting. Going through the profile bio of a user will help you to determine if the user fits your requirements.

Using Twitter for Marketing

Marketing on Twitter is easy, and this makes it an excellent choice for your business. To achieve a successful marketing campaign on Twitter, there are some steps you should take. Read on to find out more on these steps.

Twitter Profile Optimization

This is the first step towards a successful Twitter campaign. This is what your potential customers will look at first when getting to know your business.

For this reason, you must optimize the profile to leave a positive impression on these individuals.

Some actions you can take to optimize the Twitter profile include the following:

- The username should be short

- Include a description of the company in the bio

- Slot in keywords that relate to the brand when creating the bio

- The profile picture should be the official logo of your business

- Include links that direct traffic to your blog or website

Use a Schedule for Your Tweets

Consistency is vital when posting on any social media platform. A schedule can help in maintaining this consistency. Various tools can assist you in following a schedule when marketing your business on Twitter.

The schedule is essential in keeping things organized on your account and maintaining activity without the need for your physical presence. Through a schedule, you have the option of creating content at an earlier date and have it posted at the right time.

Since there are specific periods when engagement is at maximum, you want to ensure that you don't miss out on the opportunity to post content. That is one of the reasons why a schedule is crucial.

Use the Pinned Tweet Option

There are specific tweets that get more engagement from customers than others. These are the tweets you need when making use of the pinned tweet option. A pinned tweet is one that remains at the top and is visible to users as soon as they open your profile.

You can use the pinned tweet to promote a product, your website, or blog.

Get in Touch with Influencers

In every industry, there is usually an influencer. This is an account with a massive number of followers. Since you may have difficulties getting as many followers as these influencers, then hire the services of these influencers in boosting your exposure and marketing campaign.

Identify the influencers that meet your needs and then send a DM to begin communication. The right influencer is one that has high engagement on posts, an excellent strategy, and real followers. You will be surprised at how many users have fake followers such as spam accounts, bots, and inactive users.

Making Use of Twitter Ads

Despite the possibility of a successful campaign without the use of ads, you should make the most of every tool at your disposal. These ads help you to get your content across to more users on the platform. You can choose to promote your profile or a single tweet with the Twitter ads.

Create a Twitter Community for Your Business

A twitter community is one easy way to enhance brand awareness. To start building one, you begin by following other users. In general, it is common for users on Twitter to follow your account if you start following them.

This rule isn't set in stone, so don't expect everyone to do so. What you can do is to pick the right accounts to follow. These accounts include those of your customers, competitors, friends, industry influencers, and other businesses like yours.

If you use your brand logo, your customers will recognize it with ease and will decide to follow the account. Now that you have started adding participants to your community, the next step is to promote engagement. This means providing content with value, liking tweets, retweeting, and remaining active.

Instagram

Instagram Marketing Strategies for Your Business

Focus on the Quality of Your Account

The first step to excellent business marketing on Instagram is to have an outstanding account. Using a business profile can be the difference between the success and failure of your strategy. The analysis tools that the business profile offers are essential in assessing your performance and determining areas that require improvements.

When developing your profile, the bio link is a crucial area you should pay attention to. Unlike other social media platforms, the bio link is the only clickable link on Instagram. It is the only option you have if you want to redirect traffic to a landing page, blog, or website.

As a business, you must work efficiently. There is a simple trick that most Instagram accounts implement to get the most out of the bio link. This trick is to create a unique landing page.

On this landing page, every link you share on Instagram will be available. Since you will be performing various actions like giveaways, discount sales, and more, there will be a need for a new link for each activity.

Imagine you decide to give out free merchandise to your followers for a month and to obtain it they must click on the bio link. What happens if you start a discount sale on a specific product in the same month? You will have to change the link.

This means that users coming for the merchandise will be redirected to a page promoting the discount offer when they click on the bio link. This isn't the best result. To prevent this issue, you use the landing page with the different links for specific actions.

In addition to a business name that your customers can recognize, the profile picture on the account should also be easy to identify. Other parts of the bio should consist of information that will introduce your business to your followers.

Get Ahead with Instagram Stories

Instagram stories are a unique feature that allows you to create a post that lasts for 24 hours before it disappears into your archive for up to a year. By using stories, you can enhance the visibility of your posts. There are a lot of other benefits that you get from the use of Instagram stories in marketing for your business.

First, the content of your Instagram stories doesn't affect the timeline of your followers. What this means is that unlike regular posts that appear on the timeline, there is a separate section just to view stories. Since there is no interference when watching stories, it can contain as many as seven posts each day.

These stories allow users to add as many posts as they want. Nonetheless, you must not do it in excess. You want your customers to see the content of your business.

If there are too many posts on your story, people are less likely to wait to view all of them.

Instagram stories are useful in giving users a peek at what a day at the office or shop looks like. You can also use it in running promotions and contests. Your business can also add an Instagram takeover to its marketing strategy.

The Instagram takeover occurs when you agree with another business or influencer to post content on their account while they post on yours. This is a great way to promote crossover business to a new audience.

Another benefit of the Instagram story is the possibility of adding "swipe-up" links to stories. This is only available on business profiles with over 10,000 followers. Regardless, it is a cool feature since Instagram mainly supports one link that is the bio link.

Make the Most of Hashtags

Hashtags can get your business in the spotlight if used correctly. There are times when specific hashtags trend on Instagram. Creating content and attaching this hashtag can help to increase the exposure of the post.

When selecting a trending hashtag, you must pick one that relates to the services and products your business offers. It is also crucial you perform your research on why the hashtag is trending. Some hashtags trend for the wrong reasons, and using them will affect your business negatively.

You don't always have to wait until you find a trending hashtag that suits your needs. Most of the times, creating a hashtag for your business is the way to go. These are commonly referred to as brand-specific hashtags.

You can create hashtags to promote specific business activities or initiatives such as a contest or a community project.

Connect with Influencers on the Platform

Instagram has several users that can be considered influencers. These are accounts that have a massive number of followers. In some cases, most of these accounts will have more followers than your business account.

Connecting with these influencers is one of the best ways to promote your business on Instagram. The reason is simple. Most of these users have earned the trust of their followers and can influence the decisions they make.

Influencers include both celebrity influencers and micro-influencers. Like every great form of advert, getting influencers to promote your business will cost a fee. For celebrity influencers, the price will be much higher than that of the micro-influencer.

Selecting the right influencer to work with is crucial. While celebrity influencers may have millions of followers, they are usually unable to hold genuine interaction with these users. On the other hand, influencers with not more than 50,000 followers find it easier to engage with their followers. These are the influencers you should connect with.

A Brief Comparison Between Instagram and Snapchat

With so many social media apps available, it is easy to get confused when deciding on the right platform for your business. This section will give you a quick look at some of the things you should consider if you are stuck trying to decide if you should use Instagram or Snapchat for your business. Here are some answers to specific questions that can sway you in the right direction.

Number of Daily Users

For a business that focuses on reaching as many users as possible, the number on each platform matters. Instagram currently has an estimated 500 million daily active users in comparison to 203 million daily active users on Snapchat. If numbers will determine what platform is best for your business, then Instagram is the obvious choice.

Analytics

On Instagram, running a business profile provides access to the insights tool. This allows you to monitor the performance of your marketing campaign with ease. Besides, there are several free Instagram analytics tools on the internet.

Snapchat limits the accounts that can make use of its analytics tool to verified accounts. These can be the creators or official stories on the platform. Getting an excellent third-party analytics tool for your performance on Snapchat is not as easy as getting one for Instagram.

Stories

Instagram and Snapchat both offer the stories feature on their platforms. If you are going to be using this feature to engage your audience, then you must decide what platform is the most effective for this purpose.

To view stories, 68% of millennials choose Instagram over Snapchat (West, 2019).

This is an important statistic that shows what platform your business is going to get the most engagement on its stories.

Time Spent by Users Daily

The time a user spends on a platform every day is crucial in determining where your business will get the most visibility. Users on Instagram spend 53 minutes on the platform daily, while Snapchat users spend 49 minutes on the platform (West, 2019).

A difference of four minutes may not look like much, but remember, users can scroll past about ten posts in a minute.

Chapter 4: Alternative Social Media Feeds

LinkedIn

If you don't know what LinkedIn is, now is the time to learn. LinkedIn is a social media platform that is designed for professionals and businesses. The design eliminates the entertainment feature that other social platforms offer to make it unique. The site involves creating a profile that you can use in enhancing your professional image by sharing valuable content, creating content, and commenting on posts.

It allows individuals and businesses to connect with other professionals that can have a positive impact. In addition to the excellent networking qualities of the LinkedIn platform, it also offers users the option of running a marketing campaign.

Why Your Business Should be on LinkedIn

There are several reasons why LinkedIn is essential for your business. Some of these include the following:

It Improves Your Search Result Ranking

Comparing your website to a LinkedIn profile, you have a better chance of increasing your ranking on search engines like Google with a LinkedIn profile. The LinkedIn platform provides a robust network of professionals, and everyone recognizes it.

Try typing in your business name in the Google search box after creating a LinkedIn profile. You will notice your LinkedIn profile appears among the top results.

Get the Latest Industry News

If you want to stay up to date on the latest happenings in an industry, then LinkedIn can help you. With a network that includes your connections and groups, it is easy to come across important information regarding the industry.

To Monitor Your Competition

Since other businesses like yours are working on LinkedIn, you can find some vital information on the companies from their profiles. You can assess the business culture, learn insights and news, and view their employees.

Essential Actions for Business Growth When Using LinkedIn

The Participation of Your Employees is Crucial

The goal of your marketing campaign is to grow the business. This is an objective that you and your employees must actively work to achieve. So, how do you get your employees involved?

The employees you have working at your company are professionals in their various fields. Have these professionals follow the LinkedIn page of your company? The actions of your employees can enhance the visibility of your company on the LinkedIn platform.

When you post content, any employee that engages with the content will make it possible to see for members of his/her network. An additional 200 users that come across your content through your employees are significant to the growth of your business.

Join a Group

There are various groups on LinkedIn, and most of these groups focus on a specific industry. To select a group to join, pick one that focuses on your niche. You can enter multiple groups to expand your reach.

The benefits of joining groups include the opportunity to grow your network, interact with other users, and establish your business as an authority. To get others to see you as an authority, you must post content that offers value in these groups. Remaining active is also essential for success.

Be Consistent in Content Publishing

The more content you post, the higher your chances of attracting new customers. You want every user visiting your page to have lots of content to view, and this is what helps in establishing your business as an authority. An excellent way to start is to post a minimum of one content every week.

When creating content, you can include images and links to get more engagement. You also want to make it easy for users to share your content and hence the need for it to offer value. Your content doesn't always have to be about your business; content providing helpful information for viewers is essential.

One mistake you must not make on LinkedIn is to use it like other social media platforms. Sharing photos of your dog, vacation, new house, or family won't appeal to the audience on LinkedIn. Always remain professional.

Engage with Other Users

LinkedIn allows you to build a network of connections. Sending an invitation that is accepted by a user will make them one of your connections. Engaging with these new connections is vital.

In building a relationship with users in your network, you must be willing to perform actions such as commenting, liking, giving answers to questions, and actively engaging in discussions. By engaging with your network, you can develop a better relationship and enhance your visibility on the platform.

Get Endorsements and Recommendations

Businesses thrive on positive testimonials and reviews from their customers. That is what LinkedIn offers with the recommendations and endorsements. An endorsement is like an approval that you are proficient in a skill or service you provide.

A recommendation enables other users to describe the performance of your business. If you have connections that you have done business with in the past, then you can start by giving a recommendation. Pick someone you genuinely respect when making a recommendation.

This simple action can get other users to write a recommendation. Having recommendations makes your business more credible.

Creating a LinkedIn Ad

There are different formats of LinkedIn ads you can use to reach your target audience. The type of ad you need for your business may differ from others, but there are specific steps you must take to start setting up these ads. These steps are as follows:

Create a Campaign Manager Account

On LinkedIn, the campaign manager is where you perform all the activities relating to advertising. It allows users to create ads and manage existing ads. There are some vital features that the campaign manager offers, and they include:

- A view at the performance of sponsored content

- Dynamic visual reporting

- Breakdown of the demographics engaging with the ads

Select an Objective

Once you have the campaign manager set up, it is time to start creating the ad. The first step is to select an objective for the ad. You must determine what you want to achieve through the ad campaign and then choose from any of the following options:

- Conversions

- Video views

- Website visits

- Leads

Ad Targeting

Targeting is an integral part of an ad. This is what ensures that your content is reaching the right users.

The first part of the ad targeting involves selecting locations and language.

Since the location and language still covers a vast audience, you can include other features to improve the audience targeting. These features include company name, job experience, company size, job title, and so on. The option to make use of the matched audience feature is also available.

There is also an exclusionary targeting feature that you can use in removing users with a specific attribute from the list of those that will see the ad.

Select an Ad Format

The ad formats on LinkedIn are numerous, so you are going to see one that fits your requirements. Some of the ad formats on the platform will be discussed briefly later. One unique quality of the LinkedIn ads is the support for a single ad format for each ad campaign.

Setting a Budget and Schedule

I'm sure you know that these ads aren't free. Therefore, you need to set a budget to indicate how much you are willing to spend on these ads. The budget and schedule of the advertisements are set up on the same page.

On this page, you decide on a daily budget or a lifetime budget. The next part of the page is the schedule setup. This involves setting a start and end date for the ad campaign.

The final part is to choose a bid type. Will you prefer the manual or automated bid? This is when you make your choice known.

There is also the option to maximize for conversions, clicks, or impressions.

Create the Ad

Now is the time to create the actual ad. On the LinkedIn platform, there are specific details you need to include in this section. These include the following:

- Name of the Ad

- Introductory Text

- Destination URL

- Image

- Headline

- Description

When creating the ad, there is a preview pane on the side of the page. This offers a look at how the ad will appear on the desktop and mobile platforms. Using this preview, you can be sure there is no problem with your image, spellings, or links.

LinkedIn Ad Formats

Sponsored Content

This is an ad format in which content from your account is promoted to other users. It appears on their feeds and is essential for boosting brand awareness.

Sponsored Inmail

Individuals love it when a business personalizes the message they send. This is what the sponsored inmail offers. It lets you deliver messages that you tailor to a specific user.

It supports the use of links and includes a call-to-action button. They are useful in promoting content, sending invites, and generating leads.

Text Ads

These ad formats appear only on the desktop application. They are like ads you find on most other platforms and include a title, image, and description. They are usually visible on the top or right side of the feed.

Other ad formats include:

- Video ads

- Single image ads

- Carousel image ads

- Follower ads

Tips to Enhance the Performance of Your Ads

Know When to Include and Exclude Your Followers from Ads

In your ad campaign, it can be beneficial to have your followers view the ads. Other times, you are better off leaving them out of the campaign. Knowing the best time to include or exclude your followers is crucial in boosting the performance of your ads.

When trying to get new conversions, positive comments on your ads can help boost your chances of achieving your goal. Other situations include the promotion of service and release of new products. These are ad campaigns that will benefit from the input of your followers.

Since some ads can use the cost-per-click method, you want to make the most out of your money.

If your ad campaign is to generate brand awareness, then having existing customers see the ad won't be beneficial. Besides, it can cost you more money.

Point Out Your Mission in Your Ads

When you want to build brand awareness, you must be creative. An ad that points out the mission of the brand is an excellent way to attract new customers. Also, it helps in building your reputation.

You can use the ad in announcing a partnership with other local business. If this partnership offers support to the community in the form of loans or development funds, then your customers will see that your company cares. Any social activity your business engages in is useful in promoting awareness.

The Decision Makers Should Be Your Focus

This is crucial if you are trying to sell your products to other businesses. LinkedIn lets you connect with individuals that occupy senior positions in various companies. These are the individuals you want to target from the onset.

It can be frustrating to work so hard and then find out that the individuals that are showing interest in your products don't have a say in the decision-making process.

Include Excellent Storytelling

You want your customers to remember your products and your business. Give them something to remember by telling a great story. Storytelling can appeal to the emotions of your potential customer.

If your business operates in the health sector, get a customer and have them talk about how your products improved their health. This sort of storytelling gives the potential customer something to envision.

Pinterest

Pinterest is a social media platform that allows users to post images or videos known as pins. Users pin their favorite images or videos to a board. These boards act as a gallery for these pins.

As a business, using Pinterest is vital in getting an insight into the interest of your target audience. Merely going through the profile of a user can provide information on services they need, products they like, and ideas that they share. The platform is useful for all businesses, but those in these areas have a better advantage:

Female-Oriented Companies

In general, women make most of the buying decisions in their homes, and you should be targeting them. According to reports from Statista, women make up 79.5% of the total Pinterest users in 2019 (Carter, 2019). This implies that Pinterest is a platform to use if you want to attract new customers that are sure to spend on your products.

Retail Companies

The opportunity to display images of your products with a link back to your landing page makes Pinterest useful for retail companies. Unlike other platforms on which users focus on gaining followers, Pinterest users are genuinely in search of unique content. If your business account displays unique products, users will be willing to share, and there are lots of others that will want to make purchases.

Companies that Focus on Creativity

Cookery, arts, crafts, DIY projects, bakery, and fashion are some of the activities that require creativity. Individuals and businesses in these areas usually come up with unique ideas that others are eager to learn about. Uploading new ideas and tips on Pinterest is an excellent way to boost brand awareness.

Setting Up a Pinterest Account for Your Business

Pinterest offers users the option of opening a personal or business account. In this section, you will find out how to open a business account to help your brand to grow. The following are simple steps you must take:

Create the Account

On the platform, there is the option to create a business account when you log in. You can also go to the Pinterest for Business page and then select the Join as a business option. You will need to provide some details to complete the business account.

Some of the necessary details include email address and password, name of the business, and the company's website. Pinterest will also request for further information on the operations of the business. This involves selecting one of several categories, including brand, online marketplace, professional, retailer, public figure, institution/non-profit, local business, media, or other.

In addition to creating a new account, the option to convert your personal account to a business account is also available.

Add the Essential Information for a Complete Profile

The profile details make the business account more informative and appealing to your visitors. There are several details you should provide at this stage. These include a profile photo, business location, username, website, and bio.

Every detail you add when completing your profile is crucial in getting people to connect with your business. For this reason, the image you upload for the profile photo should be your logo. This is the best visual representation of your brand.

Website Verification

There are two reasons why website verification is essential for Pinterest. The first is to give you access to the Pinterest Analytics tab on your business account. The second reason is to improve your search results rankings.

In growing your business, you don't want to miss out on the opportunity to reach your audience with ease. There are two options available during the process of website verification. These include the following:

- Uploading a meta tag

- Uploading to the website

Uploading a Meta Tag

For website verification during this process, select the edit button on your profile. After this action, click on the 'Settings' option and then select 'Claim' to reveal a "confirm website" button. You can copy the code that appears when you click on this button.

The crucial step in this process is to add the code you copy to the <head> of your website. This is the index.html area of the content management system (CMS) of your website. Find the <head> section, paste the code, and save.

On the Pinterest platform, click on 'Finish' to complete the process.

Uploading to the Website

Here, you must first open the "confirm website" from the edit profile panel. On this dialog box, go to the "Download This File" option and select. As soon as this is complete, upload the file on the root server without renaming it, and select 'Finish' on Pinterest.

Pins

A 'tweet' is a term that refers to posts on Twitter. Likewise, Pinterest has a unique name for its posts. These posts are known as pins.

Most of the popular pins are high-quality images. The best size for your pin is an aspect ratio of 2:3, which can be 600 x 900 pixels (Myers, 2019). You can also post 1:1 square pin and 1:2.1 long pins.

So why do you need attractive pins on your account? The huge benefit of Pinterest is the ease with which you can redirect traffic to your website. It offers the option of adding a link to your pins.

This implies that with every pin, you can redirect followers back to your business website or eCommerce site. To improve your business presence on the platform, then it is essential that you also save useful pins that you find on other boards. The following are three ways through which you can create pins on your account:

- Create pins directly from the Pinterest platform or app

- Use an image on the internet

- Choose an image from your computer files

Create Pins Directly from the Pinterest Platform or App

Your home feed, boards, and the explore tab all offer some useful and exciting pins that can boost your page. Once you find such pins, hover over it and click on the 'Save' button. This allows you to select a board to save the pin to.

Use an Image on the Internet

The internet is a great place to find excellent images that your followers will love. Adding a superb image that you found to your Pinterest account is quite easy – as long as you have the right tool. The essential tool you need in this case is the Pinterest browser button.

You can get this button on the Pinterest platform by following the prompts to install. After completing the installation, the button appears on the toolbar as a Pinterest logo. Now, hovering over an image on your browser reveals a 'Save' button.

Clicking on the Pinterest logo on the toolbar will generate a page with all the images that appear on a website. You can then pick an image from this list and save to a board on your Pinterest account.

Choose an Image from Your Computer Files

A social media platform won't be complete if you don't have the option to upload images that are not available on the internet. To do this, look for the '+' button that appears on the bottom right corner of the Pinterest page. Click on it and select the "Create a Pin" option.

There is a frame that you can click on to upload an image from your computer. You can also choose a board, include a destination link, a title, and a description. You can then save and complete the process.

Home Feed

When you have an account on Pinterest, you can choose to follow topics, people, and boards. The options to follow boards and topics allow the personalization of the content that appears on the home feed. The home feed is where you find all the pins from these boards and people.

New pins on the home feed will appear based on the content you pin, accounts you follow, and recent activities on the platform. Accessing the home feed differs depending on how you access the Pinterest platform. On the mobile app, tap on the Pinterest logo, and click on the 'Home' button on the desktop version.

Pinterest Boards

On the Pinterest platform, there is a simple way to organize everything you pin.

This is what the Pinterest boards offer. As a business, you want your followers to find pins that relate to their interests with ease.

For each product or service you offer, it is essential that you have a unique board. Pinterest allows users to pick the boards they follow. You want to use this to your advantage.

There should be a regular update of pins on each board. Users that follow these boards will get these updates on their home feed.

Generating Sales Using Pinterest

Use Pinterest Partners

As a business, you must have as many tools as necessary to ease your task. This is what the Pinterest Partners offer. There are currently 78 partners available on Pinterest.

Some of the popular partners include the following:

- Hootsuite

- Later

- 4C

- Adglow

- Analytic Partners

- Buffer

- Drizly

- Experian

- MakeMeReach

- Shutterstock Custom

- Sidecar

- Sprout Social

Create Pins of Products

The most crucial step to take in promoting your business is to have images of your products online. As mentioned earlier, you must create boards to separate your pins. This can be according to the functions of the product or individuals that use the products.

Include a Price Tag

Taking this action automatically moves your pin into a Gifts section. To do this, type in a $ sign when inputting your pin description. In addition to moving the product pin into this section, Pinterest includes a price ribbon on the pin that is visible to other users.

Using Pinterest Ads

The Pinterest ad is a powerful tool that you must not overlook when trying to reach your target audience on the platform. Although it offers enormous benefits, the downside to the Pinterest ads is the fact that it is only available in a few countries. These include the United States, New Zealand, Australia, France, United Kingdom, Ireland, and Canada.

There are various types of Pinterest Ads that you can choose from. Your marketing strategy is often a determining factor when selecting the type of ad. The types of Pinterest ads you can find are briefly discussed.

Promoted Pins

The 'Promoted' label that appears on these pins is the most straightforward indicator that this pin is an ad.

If you overlook this aspect, there is no difference between the promoted pins and regular pins. The huge plus is that the label disappears if one of your followers decides to share the pin.

Using a promoted pin gets it on the top of the home page of your target audience. This feature makes it suitable for use when promoting brand awareness.

Promoted Video Pins

This is simply an ad that has a video instead of an image. As users scroll through their search results or home feed, any video that they come across will automatically start playing. This is as soon as more than half of the pin is on display.

Promoted Carousels

This type of ad allows you to add multiple images. It is a useful feature to have when you have several products that you want your audience to see.

Add the different pictures of the products so that users can then swipe to view the other products.

Another reason why this type of ad is beneficial is the option to add a different title, landing page, and description for each image. You may decide to have multiple images of a single product to enable you to display different parts and features.

Promoted App Pins

Having a mobile app for your business is a great step towards growth. Getting your target audience to know about it and download the app is crucial. Pinterest simplifies this process by offering Promoted Apps Pins. From the Pinterest platform, you can get users to download the app.

Setting Up Your First Ad

Creating an ad on Pinterest is straightforward. It requires a business website and the inclusion of the Pinterest tag. This tag is crucial if you are to get insights on the behavior of the visitors on your site.

Pinterest has an article on how to use the tag on their website. Actions like signup, checkout, search, PageVisit, lead, WatchVideo, ViewCategory, and custom are some of the activities you can track. The following are the steps to take when setting up an ad:

- Select a campaign objective

- Create a budget for daily spend limit

- Make an ad group

- Define your target audience

- Determine the ad placement based on your budget

- Use keywords and interests to enhance targeting

- Create a schedule

- Define a maximum bid

- Choose from the available pacing options

- Add pins to the ad group

- Pay attention to the analytics

Chapter 5: Follower Feeds

YouTube

When you think videos, YouTube is the first platform that pops up in your head. YouTube ranks second on the list of search engines, with an estimated 1.9 billion users (Smith, 2019). These facts make YouTube an excellent platform to promote your business.

Ways to Use YouTube for Business

As a social platform, there are many unique ways through which your business can benefit from having a YouTube channel. Here are some of the vital points that you need to keep in mind:

Offering Product Support

Users on the YouTube platform will pick a YouTube tutorial video over a user manual provided in the product package. This proves that you can use YouTube in meeting the needs of your current customers. There are several ways to offer support on YouTube.

The support videos can address some of the most common issues that individuals have when using your products. You can also use this opportunity to showcase additional features and functions that users can get from the product.

Using videos in the right manner will reduce both the time and money spent on customer support.

Advertising Your Products

An advert is an excellent way to introduce your product to the world. Unlike TV commercials, you can upload a high-quality advert on YouTube without incurring any additional expense. Notwithstanding, creativity is essential in getting viewers to watch the videos.

Advert videos can focus on your new product while it is in use. This means that you get a chance to demonstrate the features of the product with clear images and close-up shots of the product. Adding a link that redirects viewers to your website is also possible, and this aids in boosting sales.

Enhancing Brand Awareness

Having people know your brand is essential for the growth of your business. With YouTube, you can achieve this goal. Various brands become popular through this method.

In this case, the aim of your videos is not to advertise or offer information on a product. The videos you create are aimed at getting viewers to learn the name, logo, and other features that describe your brand. These videos are often in the form of highly entertaining commercials.

Making Your Videos Optimized for Search

To optimize your videos for search on YouTube, it is essential that you make use of keywords. When a viewer decides to search for useful videos on YouTube, there is less focus on the content in determining the right video. The spotlight focuses on the texts.

Areas like the title, description, and tags of your video are crucial in getting it to appear on the results of a search query. There are several actions you can take to optimize your video, and this section discusses these actions.

Selecting the Appropriate Keyword

The keyword is very important during the optimization process. To select the right keywords, you must put yourself in the shoes of your target audience. What words do you think they will type in when looking for the content in your video?

During your keyword research, you can come up with a list of keywords that relate to your video. Once you get the best keywords, you can then use it in the title, tag, and description of the video. The right keywords can include both specific and generic keywords.

For example, a customer that is in the market for a new phone may type in "Best android smartphone 2019" into the search query while another can type in "Best Samsung A-series smartphone." If you are involved in the sales of smartphones, both users are potential customers. The difference between them is that the latter has decided to narrow down the search.

If your goal is to offer services to users that are interested in Samsung smartphones, then your keywords should focus on this. Your list of keywords can include Samsung and A series in this case.

For the first customer, you can have more generic keywords like smartphone and Android.

Title Optimization

When you have your list of keywords, you need to think of the best ways to use them. One place you can use the keyword is in your title.

YouTube offers 100 characters for the title, but the search results only display 70 characters.

This means you must make the most of these 70 characters in adding keywords and getting viewers interested in opening the videos. Since you have a character limit, it is crucial you only select the keywords that best describe the content of the video. Avoid keyword stuffing and make the title meaningful while using the keywords.

Tag Optimization

Another place where the keywords can be used is in the tag field. What is a tag? Your keyword is referred to as a tag on the YouTube platform.

That makes the tag field the most important place to input your keywords on the platform. YouTube offers the option of slotting in your keywords while uploading a video as well as the opportunity to add it later. The tag can be a single word or multiple words.

When entering single words, simply add a space between them to separate each word. For a tag with multiple words, write the words inside a quotation mark. By analyzing the title and description of your video, YouTube will also offer some suggestions on tags that you can use.

Optimizing Your Comments

When ranking search results, YouTube uses the comments on a video. The higher the feedback on your video, the better the ranking of the video. You must have come across several videos that encourage viewers to leave comments and likes. In addition to the number of comments, a video that gets positive ratings has a better chance of getting ahead of others on the result rankings.

As a business, you must enable comments on your videos. You should also promote engagement in the comment section using your videos.

Description Optimization

The description is one of the best places to include keywords on your videos. It offers enough space to do so with ease. Nonetheless, you should do so with creativity.

If your description appears to be artificial or contains keyword stuffing, you may not get desirable results.

The additional length that a description offers makes it possible to create a high-quality copy that will seem natural. To do this, ensure you write the copy while including keywords properly within the text. If you have no idea what I mean by keyword stuffing, it includes actions like making a keyword list after the description or random insertion of keywords.

How to Boost Sales with Your Videos

The goal of marketing on YouTube is to increase the income of your business. To achieve this, there are some important steps you must take on this platform.

Offer Value in Your Videos

On YouTube, offering value in your videos means that the videos contain content that viewers want.

When they want the content, they are going to watch the videos. If you are having difficulties determining the value viewers search for, here are some tips.

Make Your Videos Informative

People like to stay informed. The information in your videos can include things like news, the latest trends, recent product releases, and so on. Anything that keeps a viewer up to date on happenings around them qualifies as content for an informative video.

Make Your Videos Educational

Earlier, I mentioned that most viewers on YouTube prefer videos over manuals. This is how you can offer value to viewers. Educational videos are those that teach viewers how to perform an action or make use of a product.

These can include makeup tutorials, game walkthroughs, how-to videos, product reviews, and DIY projects.

Make Your Videos Entertaining

If you check the majority of the most popular videos on YouTube, you find out that a lot of them are entertainment videos. People love to have a good laugh and giving them something to laugh about can get your video to go viral. As a business, this may not be as easy as it sounds.

Nonetheless, you can do your best to provide a form of entertainment to get viewers to watch your videos.

So, why are these tips essential in offering value? The trick is to avoid making your videos look like ordinary adverts. You can't expect viewers to use their bandwidth in watching adverts, TVs offer a lot of that content.

By offering value, you get the attention of the viewers. This is a crucial step in getting them to buy what you are selling.

Redirect Traffic to Your Site

The final goal is to get people to buy your products so you will have to talk about it later in the video. Just don't make the video focus on the sales pitch. Be subtle in your approach, and it will yield positive results.

A great way to redirect viewers to your website is to use the YouTube Promoted Video Plan. This supports the inclusion of a CTA overlay to videos. With this overlay, you can add a direct link to the website landing page.

Other options that you can adopt:

- Placing the URL of your website on the screen while the video plays

- Including a break in the middle of the video presentation

- Adding the website URL to the video title

Closing Sales

The final step in sales is closing. This is the point at which your potential customer becomes a paying customer. Although YouTube offers a lot of great features and functions, there is no option to sell your products on the platform.

To go on to the closing phase, the website of your business is essential. The first step is to create a unique landing page that is sure to improve the chances of closing. This means that the link you add to the videos shouldn't direct users to the home page or any other random page on your website.

For each product you are trying to sell, the link should direct users to a landing page that focuses on that product. Your landing page should make the task of purchasing the product as easy as possible. When the link redirects customers to the home page or to an about us page, you lose the chance of a potential customer making a quick purchasing decision.

YouTube Pay-Per-Click Ads

On YouTube, the form of advertising in use is the pay-per-click ads. Here, you can select a video that you want to promote, and then there is a charge when a viewer watches the video by clicking on the ad. It is different from the cost-per-thousand advertising that requires payment for ad placement.

This form of advertisement is an excellent choice for your business since you only pay when there are results.

How Does it Work?

The pay-per-click ads require payment based on cost-per-click. The first step is to select a keyword while YouTube will link this keyword to your video. If there is a search entry that includes this keyword, then your video appears.

For each keyword, you make a bid in what is known as an Ad Auction. The higher the amount you bid on a keyword, the higher your rankings, and frequency of your ad display on the search results. This is how you get ahead of your competitors.

Formats of YouTube Ads

Creating a YouTube ad can be easy, but it is vital you know the various formats that are available. Here is a quick look at the options:

Overlay Ads

These are ad formats that appear on the lower part of a video. They cover about 20% of the video you are viewing.

Non-Skippable Video Ads

These are ads that require users to watch them before they can view a video on the platform. It may appear before the video starts playing, during, or after the video.

If the video has a length of up to 30 seconds, then it is a long non-skippable ad.

Skippable Video Ads

This is a common format of video ads on the YouTube platform. These are the ads that offer the option to skip after the first 5 seconds.

Display Ads

These ads usually appear on the right side of the screen. It is an ad that provides results based on interest. What this means is that if this ad gets a click, it is because the viewer has an interest in the ad.

Bumper Ads

Short videos that can be about 6 seconds in length that viewers must watch before the video they select are known as bumper ads.

Tracking Your Performance

The only way to know if your ad campaign is doing well is to follow your performance. To do this, there are key metrics that you must observe.

You can visit the Google Ads Dashboard to monitor the following metrics:

Views

This is a metric that shows the number of viewers that watched the ad for over 30 seconds.

Cost-Per-View

This is the amount you pay every time a viewer watches your ad for more than 30 seconds.

Impressions

How many times your thumbnails were shown to viewers on YouTube.

View Rate

This is the percentage of people that watched the video after it was shown to them.

Earned Actions

This is the number of viewers that liked the video, subscribed or opened your website through the video ad.

Snapchat

Snapchat is another popular social media channel that attracts many users from the younger demographic. It supports the exchange of photos and videos between its users. Anything sent on the platform is only available for a maximum of 24 hours.

This was the foundation of what other platforms like Instagram would add in the form of stories. As a business, Snapchat provides room to reach a vast audience. In comparison to other popular channels like Twitter, with about 126 million daily users, Snapchat has an estimated 203 million daily users.

If you want to gain awareness on Snapchat, there are a few steps you can take. These include:

Promoting Flash Sales

Flash sales are deals that don't last a long time. What better way to promote these deals than through a platform where posts don't exceed a day? This is one of the benefits of Snapchat for your business.

You can use it in offering discounts and specials to your followers. You can then redirect these followers to your business website.

Share Content that Adds Personality

Customers want to connect with a business. To do this, they need content that adds personality to the company and makes it relatable. You can make this possible by sharing content that depicts life after work hours or how you enjoy the holidays.

Sponsoring a Geofilter

Regular 'Geofilters' on Snapchat are filters with location-specific details. They appear to users when they are within a specific location. You gave the ability to make one for your business.

This means that when users get close to your business location, this Geofilter will appear for them as an option to add to a photo or recording. You must pay to have one made, and it is an excellent form of business promotion on the platform.

Using Snap Ads

Another form of advertising on Snapchat is the Snap Ads. They appear while users are watching stories on the app. The video is 10 seconds long, and you can use it in redirecting users to your business app, blog post, or the full-length video.

Sponsor a Lense

The last form of paid advertisement you can use on Snapchat is a Sponsored Lense. A lense is a filter you create on the Snapchat platform. Snapchat users love to use these lenses in making their videos unique.

As a business, you can sponsor a unique lense that will be available to users of the Snapchat platform. These can transform users into anything you desire. There have been sponsored lenses from companies like Gatorade, Apple's Beats, Taco Bell, and one for the X-Men Apocalypse movie.

Snapchat Stories

Although it is similar to Instagram stories, I can't move on without mentioning the selling point of Snapchat.

Your followers can share these stories, so this makes it an excellent feature in promoting your business.

You can get creative with your stories and advertise your products in a way that is fun and entertaining. Doing this can get users to share the story. Other content you can share include how-to videos to help your followers.

Tumblr

This is another platform that offers a unique take on the idea of social media communication. The features of Tumblr are like those of a blog, but it is accurately defined as a microblogging platform. Using Tumblr for your business is very useful in promoting awareness regarding your brand.

Users on the platform can share and post content in the form of short write-ups, video, and audio.

It is an excellent platform for enhancing visibility since the posts on the platform are accessible through the web. That means both Tumblr users and non-users can view the content.

The platform supports the integration of posts into the Facebook platform, and its users are the younger demographic below age 25.

If you decide to use Tumblr in promoting your business, there are a few steps you can take. These include the following:

Give an Excellent Introduction

There is an "About Us" page on Tumblr that lets you provide information on your business for others to see. You need to use this space by giving the viewers as many details as you can. Adding links to this page helps.

You can add links to your website and other social media channels.

Get Familiar with how Tumblr Works

As a business, you are surely going to be familiar with the use of other blogging sites like WordPress.

This might cause a minor issue during your initial time on the Tumblr platform. The most noticeable problem is the limit on characters available to create content.

Take Care When Creating Your Account

Creating your Tumblr account also lets you create your first blog on the platform. This works as the default blog for your account. That means you don't want to make any mistakes here.

Remember, you are promoting your business, so the name you pick must relate to the company and be easily recognizable.

Get a Professional Theme

If you want to customize your Tumblr theme, then this option is present. Use this to your advantage when making your Tumblr account different from your competitors.

You should hire the services of a professional designer.

Having a unique business theme on display will make your visitors recognize your page. If you include the company logo on the theme, then you will make it possible for everyone that visits your blog to remember your brand visuals.

Remain Active

Being active on the platform means you reblog, follow, and like the content. It also involves you posting content of value. You won't attract your target audience if you limit your activities to liking and reblogging content published by others.

Let people see what your business has to offer in your posts. Create content that is engaging and useful to others on the platform. What should you post?

Deciding what to post is easy. You can post anything. When starting the account, you need to get accustomed to posting content.

Start by posting videos or photos. You can then try creating articles. Some simple ideas include writing helpful tips on a topic or documenting your observations on a subject matter.

Three posts per day is a good start when developing your account. Remember, you should also reblog. You can find great content to reblog by searching for a topic that interests you on the platform.

Be Smart with Your Use of Tags

The unique way to track content on Tumblr is to use a tag. The tags are attached to the posts and usually appear at the bottom when you hover over it.

Typing in any of the tags on a post in the search box will show other posts with a similar tag.

If you find a post on a topic relating to your brand, and it has a lot of engagement, you can use this tag when creating your post. Posts with a lot of engagement will have many users tracking them so you can use this to enhance the visibility of your post.

Use Other Features that Tumblr Offers Effectively

One of the additional features you should be using is the feature to create additional blogs. These are blogs that you can use for a specific purpose and then delete it once you achieve your goal. An example will be to create a blog to promote an event.

You can post content relating to this event on this blog to build up momentum towards its arrival. Once the event was held, there is no need for the blog and its contents. So, you can delete the blog.

Another feature is the use of Google Analytics in tracking your blog. It is useful to know the traffic your blog is getting or to analyze data. Other features include the integration of the Disqus tool for commenting and use of a custom domain name on a blog.

Entertain with Images

Images can get you more engagement on Tumblr. A common way to do this is to post memes. You can use memes that relate to your company and help to tell a brand story.

Other fun images like GIFs are also essential in promoting content. It is especially useful if there is a need to share a link to your followers. Entertaining images are shared frequently on this platform.

Chapter 6: Promoting and Advertising

Local SEO

What is Local SEO?

Local Search Engine Optimization marketing is a unique form of marketing that focuses on the optimization of your website and marketing efforts to improve your rankings on a local search. The goal is to make your business visible to customers around your location anytime they need the products or services you offer. This is a valuable tool to get customers to visit your storefront or establishment.

Local Search? What is it?

I mentioned a local search while explaining what the local SEO means. A local search is simply a search entry that includes "near me" or a location. Since Google has information on your current location, adding "near me" restricts the search results to those close to that location.

For a simple example, if you need a plumber in Montgomery, Alabama, just type "auto repair shops near me" and the search engine will produce results that consist of auto repair shops located in Montgomery. The same result will appear if you change the entry to "auto repair shops in Montgomery, Alabama."

Local Pack

The local pack or local 3-pack refers to the map and list of three businesses that appear as the result of a local search. There are unique features of the local 3-pack that make it different from a regular search result. This difference is noticeable in the inclusion of reviews ratings, photos, opening and closing times, address, directions, and website.

Having a Google My Business profile helps in the local search since the information that appears is from this profile.

Building a Citation

A citation is essential for your local SEO. The citation can be a business listing website or online directory that has the name, address, phone number, and website URL of your business.

For it to be a citation, these four details must be available on the directory or listing.

Without a citation, your business won't appear on a local search. Citations can be structured or unstructured. The structured citation is noticeable on review sites and other business listings. The form fields you complete for a Yelp listing is an example of a structured citation.

The unstructured citation appears on a web page or content like news piece without any structure in the format. You can set up citations on well-known websites for success.

Factors that Affect the Local Search Results

Three main factors influence local search results. Your influence on these three factors is minimal. They include the following:

- Relevance: Are the products and services you offer a good fit for the search query?

- Location: Is your business located near the individual performing the search?

- Reputation: What do your customers and other individuals that have been in contact with your business have to say?

Tips for Your Local SEO

In improving your local SEO, there are a few things you must always remember to do. These are simple steps that you may have overlooked before now. As you read through this section, ensure you act on these tips.

Create Your Business Page on Google My Business

One of the most important online directories that should have information on your business is Google My Business.

Once you have a profile set up on this directory, your business will become visible on the results of a local search. Besides, it also places it on Google Maps.

Since Google is the most popular search engine, most people forget other search engines like Bing. You can also visit Bing Places for Business to set up a profile. Nothing beats covering all the grey areas.

Localizing Your Website

When you decide to engage in website localization, what you do is to add the necessary information to your website. This involves including your name of your region or city. Some businesses run out of several locations.

If your business falls within this category, then you have created a unique page for each store location.

Ratings and Review Management

There are review sites on which customers can voice their opinions on your products and services in addition to rating your business. These reviews and ratings affect your local search ranking. If the review sites are credible and well-known, then search engines will use the reviews from the website in ranking your business.

Building Citation

As discussed earlier, it is essential in your local SEO marketing strategy.

Backlinks

If there are backlinks from authority sites to your website, then your site is seen as credible and reliable. This is according to the search engines – and they are what matters most in this case.

The backlinks can come from business associations, newspaper articles, or blogs.

Review Marketing

Review marketing refers to the process of enhancing your brand credibility and visibility through reviews. Unlike other forms of social media marketing, your input in the review marketing is minimal. The customers are responsible for the performance of your business.

This form of marketing is important due to the impact of customer reviews on the purchasing decision on a prospect. It is similar to word-of-mouth recommendations you get from your customers.

To get the most out of review marketing, follow these tips.

Get Your Business Listed

Several review sites are in use today. Getting your business on these sites is essential to benefit from reviews. When your business appears on a review site, the profile is often called a listing.

Although it is often your role to create your listing, your customers can decide to do so if you don't. This is when you must claim the listing. The process of claiming the listing differs from that of creating one, but you must complete it.

Improve Your Products and Services Based on Reviews

A review is a customer telling you how they feel about your services and products. Not just you, but the whole world will also know how this user feels. Take time to go through this review.

If it is a genuine review by one of your customers, it is time to identify a part of your business that you need to work on. The reason why this review is critical is the value it offers. Unlike other customers that leave your business without stating a reason, this review describes what went wrong so you can make changes and make sure it won't happen again.

There are times when you find a review that gives details that seem out of place. It is common for competitors to try and bring down other businesses using review sites. There are specific policies in place to solve such problems.

Keep an Eye on Your Profiles

The only way to get the most out of the review sites is to know when something new happens. If a customer posts a review, you need to know as soon as it happens.

This can help in engaging with customers.

Saying a thank you for a positive review is necessary. In the same way, you must respond to the negatives. The positive reviews can aid in boosting the other marketing campaigns of your business.

Use the Advertising Features

Review sites also offer premium features like advertising to various businesses. On a few of these review sites, paying for the services of the site will enable you to select the review that appears.

This means that you can get customers to see the best review on your listing. This is how you use the review marketing to your advantage. Regardless, you still have work to limit the negative reviews you get.

Most customers go through all the reviews on your listing before making their decisions. If they find too many negative reviews, you can expect to lose them.

Work for More Positive Reviews

Things don't always go according to plan. Therefore, you may keep getting negative reviews despite making so many changes. In truth, most customers are likely going to post on the review sites when they have something negative to say compared to when it is a positive experience.

You must get your loyal customers to post reviews. Create content to enlighten your customers on how they can help grow your business with their reviews. It is possible to simplify their task by giving a guide on how to write these reviews.

As a rule, make sure you don't pay to get reviews. Not only does this go against the policy of most review sites, but the reviews you get from such action also are usually not genuine.

Popular Review Sites

There are several review sites available for customers to use in assessing any business they have an interest in. These sites help them to determine the credibility of your brand and the quality of services you offer. In this section, we will look at two popular review sites.

Google My Business

This is a site that contains a profile of your business on the Google platform. Getting a profile on this platform involves creating one or claiming an already existing listing. Details of your business on the platform are very crucial.

A branded business search, Google Map search results, and the local pack are some of the places where this information is essential. The search result of a branded search is referred to as the Knowledge panel, and it appears on the right side of your desktop screen.

The profile of your business can contain information like the opening times, contact details, category, description, and services or products you offer. These are the details you can add to your profile. Other information on the profile depends on the input of customers.

These details include the GMB Q&A, Google Reviews, and GMB attributes. Considering how Google My Business platform functions, it is an excellent example of a citation. To improve your chances of a high rank make sure to include regular updates of the business profile on Google My Business.

Yelp

Another popular review site that your business should be using is Yelp. On this platform, customers have the option of posting a review and giving your business a rating from one to five stars. Both businesses and consumers have the option of creating a profile on the platform.

The profile of your business on Yelp includes a location and the operating hours.

Like any other review site, having many positive reviews will offer significant benefits to the company. Yelp customers perform a more in-depth analysis of a business profile they are interested in.

The reason why customers on the platform take more time to view the reviews is due to accusations that they promote a business that pays for advertisements better than those that don't. For this reason, a company with excellent services and reviews may be pushed down the search results to make way for others willing to pay.

Other review sites can help enhance the local SEO of your business. These include:

- Choice

- TripAdvisor

- Yahoo! Local Listing

- ConsumerReports

- Glassdoor

- Amazon Customer Reviews

Email Marketing

What is Email Marketing?

Email marketing refers to the marketing process in which you use emails in reaching your target audience. The emails are used in converting potential customers into paying customers, advertise new products to existing customers, and providing updates on the recent happenings in your business and industry. This is one of the oldest forms of online marketing.

The current issue with email marketing is the fact that most people overlook the possibilities it offers.

Email Marketing Statistics That You Should Know

The statistics given below are essential in getting you to understand why you need to include email marketing in your overall marketing strategy. Without wasting much time, let's see some key facts and figures:

1. In 2019, an estimated 5.6 billion active email accounts will exist.

2. Business communication through emails is a better option according to 73% of millennials.

3. Checking emails is a daily routine for 99% of consumers.

4. Customer retention is improved by email marketing according to 80% of business professionals.

5. Email marketing played a vital role in the purchasing decision of 59% of the participants.

6. Email marketing has a 3,800% ROI, which is equivalent to $38 for every $1 spent.

7. According to these statistics (Forsey, 2019), ignoring email marketing any further will lead to more harm than good.

A Quick Guide to Using Email Marketing

In this section, I will introduce simple steps you can take to start your email marketing campaign. If you follow these steps, you should be ready to run a successful email marketing campaign with ease.

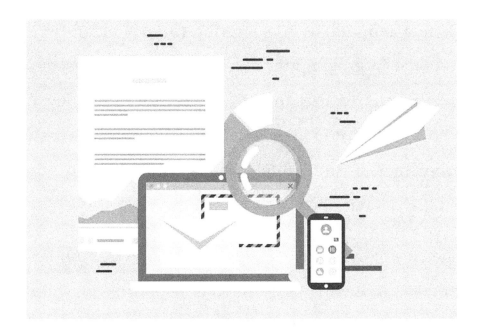

Build an Email List

What is this email list? An email list contains the email addresses of every individual that has subscribed to your email marketing campaign. These are individuals that want to receive the emails you send during the campaign.

Getting individuals to subscribe to your email list is essential in growing the list. One trick to get users to subscribe is to use an opt-in form on your blog or website. An opt-in form is a signup form that serves as proof that an individual has permitted you to send emails to their inbox.

The opt-in form also contains information on your lead magnet and why users should subscribe to get it. Individuals won't subscribe if they don't get anything in return. A lead magnet refers to anything that you offer to an internet user to get them to complete the opt-in form.

A lead magnet can be any of the following:

- Quiz

- Webinar

- eBooks

- White paper

- PDFs

- Free trial

The lead magnet you offer should be one that is relevant, available for rapid consumption, and that can be received instantly. The next step is to create the opt-in form. This form should be optimized to improve conversions.

Be sure not to force anyone to receive your emails. Actions like adding emails from business cards or social media profiles won't help. A user can lodge a spam complaint against your address.

Should You Buy an Email List?

When you are desperate to get quick results, you may decide to purchase an email list. This may seem like a good idea, but I strongly advise against this course of action. There is a simple reason for this.

Most email lists you purchase often contain a combination of active users, inactive users, and spam addresses. In email marketing, the term bounce is essential. A bounce occurs when an email fails to deliver.

It can be a hard bounce or soft bounce. A soft bounce is temporary and may occur if the inbox of the receiver is full. You can resend the email to the same account later.

With a hard bounce, there is no possibility of the email address receiving the email. This is often due to a wrong domain name, or a closed address.

The issue with this is that hard bounces result in penalties from email service providers.

If you continuously send emails to inactive addresses, your sender address is tagged spam. As a result, your emails to everyone, including your actual subscribers, go directly into the spam folder.

Choose an Email Service Provider

An email service provider is a company offering various tools to aid in your email marketing campaign. These tools include automation, personalization, customizable template, analytics tools, and more. There are several email service providers, and some of the most popular include:

- MailChimp

- SendinBlue

- Constant Contact

- GetResponse

- Campaign Monitor

- ConvertKit

Email List Segmentation

The list segmentation is a process that is essential for the success of your email marketing campaign. It involves creating smaller groups out of your main email list. This is to ensure that you are sending the right message to an email address.

Your email list consists of the email addresses of all users that have opted-in to receive your emails. This list includes both prospects and loyal customers.

Since the prospects are still at the top level of the sales funnel, the content you need to send to them differs from the loyal customers that are at the bottom of the funnel.

Through email list segmentation, you can separate these email addresses. There are several options you can use when you decide to perform list segmentation. These include segmentation by:

- Lead magnet

- Preference

- Open rates

- Inactivity

- Location

- New subscribers

- Cart abandonment

Use Autoresponders

When you sign up on most websites, the first email you receive is a confirmation email followed by others that provide information on the company, the products it offers, and so on. These emails are usually sent automatically.

These are autoresponders. It refers to a series of emails that you send to an email address when they perform an action that you set as the trigger.

This action can be subscribing to your email list, purchasing a product, or cart abandonment.

The content for these emails is developed at an earlier date and then scheduled for delivery at the right time. This is one of the tools that you get from the email service provider. An excellent autoresponder series is one that nurtures your leads and then converts.

Google Ads

Google Ads is a platform that offers paid advertising services. It was launched as Google Adwords in 2000, but the name was later changed to Google Ads in 2018. The form of advertising on Google Ads is based on the pay-per-click (PPC) model.

There are some essential terms that you must learn if you want to start using the features that are available on Google Ads. These are as follows:

Bidding

The Google Ads model uses a bidding system in running its ads. For each ad click, the system allows advertisers to decide on a suitable amount and then to make a bid. This bid is the amount an advertiser wants to pay for each click.

The bidding options that Google Ad offers include:

- Cost per engagement (CPE): this is how much you pay when an individual performs a pre-agreed action.

- Cost per click: this is the price for every ad click you get during the campaign,

- Cost per mille (CPM): this is the price you must pay as soon as a thousand visitors view your ad.

Conversion Rate

This refers to the ratio of individuals that complete an action on your website, to the total number of visitors.

Ad Rank

The Ad Rank is the determining factor in the position or placement of your ads. To get the Ad Rank, the ad relevance, time of search, search terms, bid amount, device, landing page experience, and some other criteria are used.

A high Ad Rank means that your ad will appear in a better position than other ads on the page.

Click-Through-Rate (CTR)

This refers to the proportion of ad clicks to the number of ad views. These are just a few terms that you will come across when working with Google Ads. There are more terms to know, but the Google Ads Help page offers a glossary of these terms.

Types of Ad Campaigns

Google Ads offers various campaign options to meet the needs of different advertisers. Here is a look at these ad types:

Display Ads

There is a Google Display network that is a collection of various websites that support Google Ads display.

Being on this network is also beneficial to the websites. The owner of the site receives payment per ad impressions or clicks.

The websites on the Google Display network cut across various industries. This makes it possible for advertisers to get their content in front of a target audience that matches the persona they have developed. When Google opens a search result, it is common to find App, and shopping campaigns display ads.

Most of the display ads usually feature high-quality images to get the attention of page visitors.

Search Ads

The search ads, in my opinion, are the most visible ad type. The reason for this is that they appear directly on Google.

Considering that this is the go-to place for most information on the internet, it is an excellent position for your ads.

You will have noticed a few of these ads when trying to get information on the internet. The ad is like a regular result in all aspects except for the inclusion of a small box with the text 'Ad' in front of the link.

Video Ads

These are ads that usually appear on YouTube videos. As one of the subsidiaries of Google, YouTube operates as a search engine that also supports the ads feature. Video ads are those that appear before, in the middle, or after the video.

It is also common to have a specific video that appears as an ad in the search result — these function similarly to search ads.

Match Types in Google Ads

Not all ads are directly related to the search entry of a user. The match type is a feature that makes this possible on Google Ads. As a business, you don't want to reach as many users as possible.

The power to decide is in your hands. You can get your ads to appear if there is a close relationship between your keywords and the search entry or only if the entry is a replica. These are some of the match types:

Exact Match

This is a match type in which the order of the keyword phrase must be maintained in a search entry for the ad to appear. In such a match type, if your keyword phrase is written as "best American resorts," it will pop up for a search entry like "best American resorts to visit."

Phrase Match

This is when you use a keyword phrase in setting up the ad and requires the search entry to match the order of words in the phrase. If there are certain words added before or after the phrase, it is still considered a match.

For example, if your keyword phrase is "home building tips," then your ad will appear for entries like "home building tips and tricks" or "easy home building tips."

Broad Match

This is a match type that matches your ad to any search entry regardless of the word or order. In this case, a phrase like "the best budget smartphone" will match search entries like "best smartphone" and "budget smartphone."

Modified Broad Match

This is when you decide that a specific keyword must appear in a search entry before your ad appears. To do this, you add a '+' to the keyword. In this case, if your keyword phrase is written as "best +budget smartphones 2019", then your ad will appear for "budget smartphones" but won't appear for "best smartphones 2019."

The match type you select depends on how well you know your target audience. A broad match is an excellent option if you have no idea what they are likely going to type in a search entry.

Google Ad Extensions

Ad extensions provide more information on your ads. These are free and very useful in getting ad clicks. There are five ad extensions that you can use, and they include the following:

Call Extensions

These are extensions that allow the inclusion of a phone number in the ad. This is an excellent ad extension to use if you want to get customers to talk to a customer service representative. With the phone number, they have a quick way to contact these representatives.

App Extensions

If you have an app that you know your customers can benefit from, then use this extension to add a download link. This is an excellent addition for mobile users, and it helps save time.

Sitelink Extensions

These are additional links that you include on the ad. These links redirect users back to the website.

Offer Extensions

Are you offering a discount or running a promotion? The "offer extensions" help you to take advantage of any of these in getting users to click your ad. Visible offers on your ads will get users to click on it instead of other advertisements that appear.

Location Extension

If your business has a storefront for its operations, then the location extension is an excellent way to direct individuals to the storefront. When you include this location, Google provides a map that individuals can use to find you.

Retargeting with Google Ads

Retargeting is the process through which you try to reach users that you failed to convert despite their visit to your website at one point or interaction with your business. Another common term used for retargeting is remarketing.

Since most users don't convert during the first contact, you must try to reach them multiple times. The retargeting process that Google Ads provides uses cookies in following these users to the various websites and platforms they visit on the internet.

On these websites, your ads will display to get the attention of these users.

Using Google Ads with Google Analytics

Google Ads is a paid advertising campaign, so it is essential that you can assess the performance of this campaign. After the set up of this campaign, linking it with Google Analytics can simplify the tracking process. Setting up a Google Ad is straightforward.

Input "Google Ads" in your search entry and click on the first search result (it's an ad by the way). On the home page, you will find a "Start Now" button that you should click on. From here, follow the steps that appear on the screen to complete your ad.

Google Analytics is an excellent tracking tool that you should be using if you want to monitor your performance on any marketing campaign.

These include your email marketing and social media marketing campaign. It allows you to track various metrics and analyze them to improve your marketing efforts.

To track your Google Ads performance, you can take this step:

Include a UTM Code

If you want Google Analytics to monitor the activities on a specific link, then you need an Urchin Tracking Module (UTM) code. It is common for most people to be unable to point out a UTM code – despite seeing it frequently. The part after the question mark on a URL is the UTM code.

Using UTM codes, you can determine what you are doing well and where you need to improve upon. Google Analytics can give you information on the ad that produced a conversion in your campaign, so you have an idea of what is working.

The main reason why most people shy away from the use of UTM codes is the need to input all your details again every time you must use the code. To simplify the process, there is a way to do it just once. All you need to do is include the code on the campaign level.

The first step to take is to open your Google Ads dashboard and click on campaign settings. On the settings page, select all the campaigns on the list before clicking on the edit button on the top. From the drop-down menu that appears, select the "Change tracking templates" option.

Click on the "Set tracking template" and paste your UTM in the box. This will complete the account level tracking.

Conclusion

Reading through this book hopefully opened your eyes to some things you can implement and grow your business. When you learn something new, it's best to put it into practice and make it easier to commit to memory.

There were many new ideas introduced in this book. The first chapter was a look at the history of social media and how things have changed over the years. When reminiscing and thinking of the early days, I don't think it would have been possible for me to earn as much money from my business before the advancement of social media.

In this chapter, there was also an overview of social media marketing and trends that you should look out for when developing your social media strategy in the coming years.

Did you have a look at why you need social media and SEO for your business? Of course, you wouldn't want to miss out on that part.

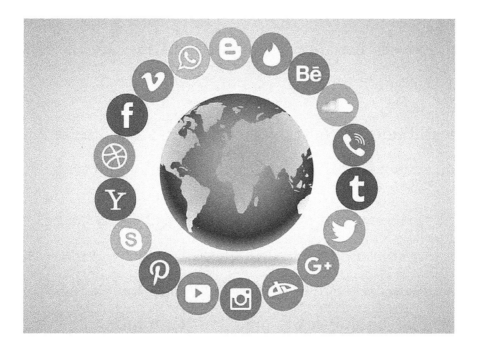

Going straight into the process of developing a brand strategy, I gave you details on how you can create a brand that stands out. This was followed by a look at content marketing for your campaign.

After covering the introductory aspects of digital marketing, I moved on to give you simple tips that can move your business ahead of the competitors on various platforms. Each social media platform is unique in certain aspects, but there are a few similarities in how they operate.

In addition to the popular platforms for marketing your business, others are slowly becoming popular.

The final part of this book was a look at the Local SEO, review marketing, email marketing, and Google ads. These are all crucial parts of digital marketing that can generate unique leads and new customers that you can't reach on other social media platforms.

Everything mentioned above was promised in the introduction. I made sure to deliver on this promise. It is now time for you as the business owner to play your role.

In growing your business, there is no room for passive input. You must be actively involved in various things that can boost growth. Digital marketing is one of these things you can do.

It doesn't have to be your final stop, but it must be an integral part of your strategy for business growth.

References

Carter, R. (2019). 10 Pinterest statistics marketers must know in 2019. Retrieved 26 August 2019, from https://sproutsocial.com/insights/pinterest-statistics/

Forsey, C. (2019). The Ultimate List of Email Marketing Stats for 2019. Retrieved 30 August 2019, from https://blog.hubspot.com/marketing/email-marketing-stats

Myers, L. (2019). Are You Using the Best Pinterest Pin Size for 2019?. Retrieved 24 August 2019, from https://louisem.com/228434/pinterest-pin-size

Smith, K. (2019). 52 Fascinating and Incredible YouTube Statistics. Retrieved 26 August 2019, from https://www.brandwatch.com/blog/youtube-stats/

West, C. (2019). 17 Instagram stats marketers need to know for 2019. Retrieved 2 September 2019, from https://sproutsocial.com/insights/instagram-stats/

CPSIA information can be obtained
at www.ICGtesting.com
Printed in the USA
LVHW081001030120
642435LV00015B/527/P

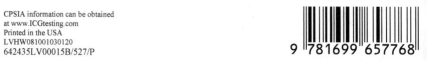